IMAGES
of America

LAKE TAHOE

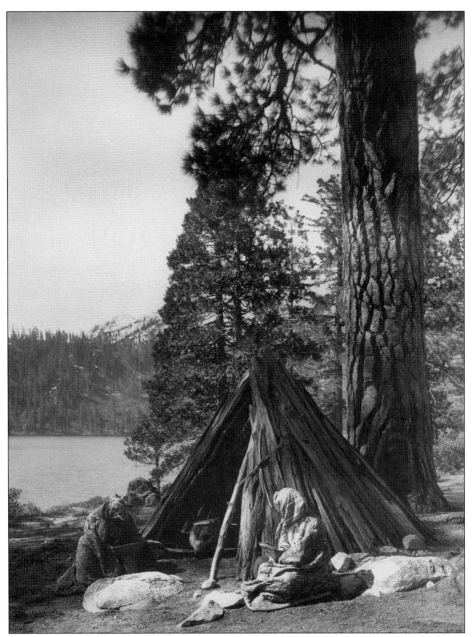

The identification on this *c.* 1910 photograph, "Native American women in front of teepee," is inaccurate. The structure is actually a *galis dangal*, known in lay terms as a winter house. These shelters were usually 12 to 15 feet in diameter—bark slabs leaning against a structure of poles with a fire pit in the center. According to contemporary knowledge, the doors always faced east. Given the disruptive history of contact, it is a testament to the Washoe that any patterns of their culture remain. Elements of tradition have indeed survived, and contemporary Washoe journey to Lake Tahoe each summer. They come from homes in the Carson and Antelope Valleys and from around Honey and Washoe Lakes, camping on beaches and in the forests, gathering traditional harvests such as fish, greens, berries, herbs, and medicines. (Courtesy of the North Lake Tahoe Historical Society.)

IMAGES
of America

LAKE TAHOE

Peter Goin

Published by Arcadia Publishing
Charleston SC, Chicago IL, Portsmouth NH, San Francisco CA

Printed in the United States of America

Library of Congress Catalog Card Number: 2005927992

For all general information contact Arcadia Publishing at:
Telephone 843-853-2070
Fax 843-853-0044
E-mail sales@arcadiapublishing.com
For customer service and orders:
Toll-Free 1-888-313-2665

Visit us on the Internet at www.arcadiapublishing.com

ACKNOWLEDGMENTS

There are many people who have helped make this book possible, including those anonymous photographers whose visions help define this place we call Lake Tahoe. But a few good folks provided humor, gracious understanding, and unselfish assistance in the construction of this book, and so deserve special mention. Without the support of the staff of four photographic repositories, this book could not have happened. They are Bill Kingman and Betty Mitchell from the South Lake Tahoe Historical Society, Lee Brumbaugh from the Nevada Historical Society, Robert E. Blesse and Kathryn Totton from the Special Collections Department, Getchell Library, University of Nevada, Reno, and Sara Larson from the North Lake Tahoe Historical Society. Dr. Darla Garey-Sage provided invaluable assistance with the Washoe photographs, and Greg Janess printed late into the evenings, providing work prints for research and captioning. Also, let us not forget Melissa M. Clark, my daughters Dana and Kari, Dr. Catherine S. Fowler, and all those who endured my late nights attempting yet another review of historical information. Finally Megan M. Berner, one of the best interns I have ever had at the University of Nevada, Reno, deserves special mention, as does the Dean's Office at the College of Liberal Arts at the University of Nevada, Reno.

CONTENTS

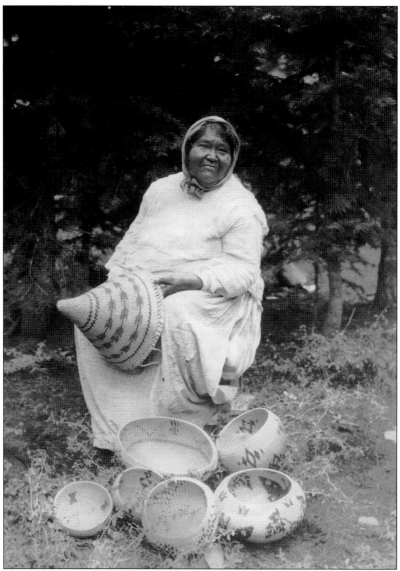

The Washoe excel at basket making, producing eloquent designs that fall well within the definition of fine art. Originally producing for domestic use, by 1895 a few notable Washoe weavers were making baskets for sale to tourists and collectors. Inevitably, the popularity and financial status awarded to weavers encouraged innovative designs aimed at that tourist market. Perhaps most well-known are the baskets of Louisa Keyser (Dat-So-La-Lee), who apparently had several other names as well. Each basket sold was accompanied by a certificate of authenticity initialed with her handprint. While her baskets were meticulously designed and crafted, including a novel round shape called *degikup*, they did not incorporate traditional religious or cultural symbols. But purchasers of ethnic artifacts wanted more than baskets; they wanted "special" stories to imbue them with meaning. So Abe and Amy Cohn, proprietors of stores in Carson City and at the lake, created myths to fit the designs, thereby pleasing customers willing to pay a premium price. These stories have become a sort of faux oral history, as they are retold and embellished over the years. Apparently very few, if any, of the stories are true. (Henry Collection, courtesy of the North Lake Tahoe Historical Society.)

PREFACE

The photographs in this volume derive principally from four repositories: the Nevada Historical Society, the North Lake Tahoe Historical Society, the South Lake Tahoe Historical Society, and the Special Collections Department at the University of Nevada, Reno. There are, of course, numerous other archives with substantial visual holdings both in California and Nevada. But I chose these four repositories because they are located within the Lake Tahoe region itself, and collectively offer a foundation of its visual history. They are the four cornerstones of this book.

In the modern era, history is in part reconstructed via the photographic image. Yet over time, many photographs are lost, due to the intrinsic decay of the image itself or because they were not carefully preserved by their successive caretakers or owners. In still other cases, images may have been lost or damaged due to unanticipated circumstances or calamities. Any interpretation of history depends upon available evidence and creative selection, that process by which historians at various levels of craft or knowledge write about or publish certain images. This is an obvious factor in determining which images survive into print. Nonprofit historical societies working in the public's interest are critical in this process as they become repositories for the artifacts of our collective history.

Over time, certain images become archetypal and are forever destined to represent a far larger and more real pictorial history. Lake Tahoe has its fair share of such images, those that are nearly "required" as representative of this place. A few of those are included here, naturally. But the wonderful value of a book such as this is that it provides an opportunity to bring into print images rarely or never before published, adding to the historical record and to our knowledge of who we were and where we lived or visited. Lake Tahoe is a spectacular natural landscape, more managed and "designed" than most people realize. While Lake Tahoe's visual history is also similarly selected and "designed," this book represents my humble effort to broaden our understanding of how this place, Lake Tahoe, evolved in our mind's eye over time.

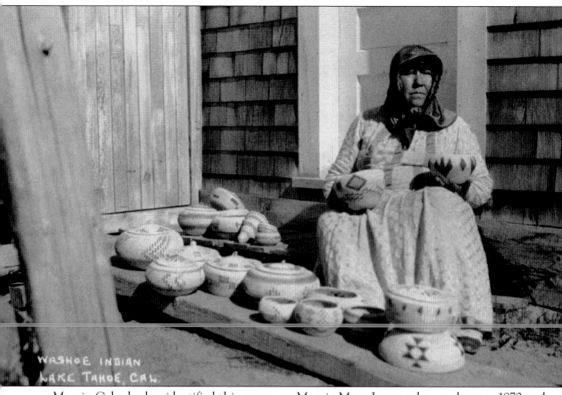

Marvin Cahodas has identified this weaver as Maggie Mayo James, who was born *c.* 1870 and died in 1952. She is considered one of the major weavers of the Washoe fancy basketry period (1895–1935), a time when weavers began to make baskets for collectors and tourists. Maggie is holding a basket that is now in the collection of the Robert H. Lowie Museum of Anthropology at the University of California, Berkeley. The photograph was made *c.* 1927, at Tallac. (Courtesy of Special Collections, University of Nevada, Reno.)

VISUALIZING LAKE TAHOE

[A]t last the Lake burst upon us—a noble sheet of blue water lifted six thousand three hundred feet above the level of the sea, and walled in by a rim of snow-clad mountain peaks that towered aloft full three thousand fee higher still! . . . As it lay there with the shadows of the mountains brilliantly photographed upon its still surface I thought it must surely be the fairest picture the whole earth affords.

So wrote Samuel Clemens, known more popularly as Mark Twain, in *Roughing It*. He was, as almost everyone is, impressed. Lake Tahoe's natural variety and scenic beauty is spectacular, witnessed annually by literally millions of visitors from all over the world. As the watershed surrounding Tahoe exceeds 500 square miles, the basin serves as an immense reservoir of snow and ice that builds up during winter months. For almost anyone who visits its blue, clear waters, Lake Tahoe is an exceptional alpine lake. In spite of its elevation, Tahoe never freezes over; its water is perpetually in motion. The lake's only outlet, the Truckee River, flows into its terminus at Pyramid Lake, and with the diversion of its waters at Derby Dam, into irrigation canals for agricultural use around Fallon, Nevada. In practice, and throughout western history, water has been perceived as an abstract legal right rather than the physical and spiritual source of life itself, and the waters of Lake Tahoe have been central in this continuing debate. Shared by California and Nevada, Lake Tahoe and its water exist under the political jurisdiction of two states, five counties, an incorporated city, several towns, and numerous fire, sewage, water, federal, state, and county agencies. But this hasn't always been the case.

Some say people first began to live in the Sierra Nevada around 10,000 years ago. The native group most associated with the Tahoe Basin is the Washoe, although the lake probably had other visitors including the Maidu, Miwok, and Paiute. The Sierra, with its high mountain meadows, alpine lakes and streams, and lower elevation valleys, offered an environment of relative abundance. Seeds, bulbs, berries, herbs, and grasses grew in the meadows, providing both food and medicine. Fish, a resource of immense importance, were found in Lake Tahoe and the mountain streams flowing down the western slope. Water, a valuable and sacred resource, fostered the growth of trees and plants used for shelter, food, and medicine. Game animals, both large and small, roamed the valleys, and plants yielded prodigious seed harvests.

Euro-Americans penetrated the Sierra Nevada early in the era of contact (15th–19th centuries), introducing disease, animals (mainly cattle and sheep), and resource use patterns (farming, ranching, commercial fishing, and mining) that disturbed, if not destroyed, native habitats and populations.

Cultural patterns of native people were severely altered by the introduction of previously unknown elements, such as guns and liquor, and by exclusion from their traditional lands and resources. Clearly, the period from 1845 to 1855 was the most devastating, as some sources estimate that the native population was reduced by as much as 80 percent. The search for gold was especially feverous, compounding the effects of biological and viral fevers to which native populations were most susceptible. By 1900, only a few thousand natives in all of California survived the overwhelming onslaught.

The first sighting of Lake Tahoe by a non-native is usually described as if no human had ever seen it before, or as if it was divinely directed. Conventional wisdom holds that John C. Fremont was the first Euro-American to record an observation of Lake Tahoe. During 1843, Fremont, a lieutenant in the U.S. Corps of Engineers, was sent to survey the West to Oregon and the Pacific Coast. With him were 39 men, including several French Canadians, a black man, several Delaware Indians, Creoles, and two legendary mountain men: "Broken Hand" Fitzpatrick and Christopher "Kit" Carson. Fremont completed his work along the Columbia River and headed south, into the previously unexplored Great Basin, attempting to locate legendary rivers, lakes, and majestic mountains reported in the area. His path carried him into what is now called Pyramid Lake, so named by Fremont after the tufa formation reminiscent on first view of Egyptian pyramids. He named the river leading into the lake the Salmon Trout River, renamed the Truckee River only a few years later.

Fighting difficult winter climate and finally reaching an overlook, Fremont gazed upon Lake Tahoe from what is generally assumed to be Red Lake Peak. He named the lake after French botanist and explorer Jacques Bonpland, but except for this brief period, that name was never officially used. Charles Preuss, an Austrian immigrant and Fremont's cartographer, labeled it Mountain Lake on his maps, and this name was used by many subsequent cartographers. Fremont was aware of the Washoe name for the lake, *Tah-ve*, as he spelled it in his diary. The Washoe word for lake, in general, is *da ow*, and this term also identifies Lake Tahoe specifically, as well as the expanded *da ow a ga*, meaning, "the edge of the lake." Common thought is that *da ow* evolved into the contemporary Tahoe. Different interpretations indicate that *da ow* meant "life sustaining water" or "big water."

Yet this name was not immediately transferred to maps. Lake Tahoe's first Euro-American name was probably Mountain Lake, followed by numerous others, including Big Truckee Lake, Lake Bonpland, and even the rather odd "Lake Sanatoria." On many maps, Tahoe is named Lake Bigler, after the third governor of California. Used in official documents, the name was apparently controversial, perhaps because it lacked lyricism or because Governor Bigler supported the Confederacy during the Civil War, or because the lake already had a popular name. It wasn't until 1945 that the California Legislature bowed to the inevitable common term, Tahoe, and officially recognized Lake Tahoe as its proper name.

Early Euro-American settlements around the lake provided supplies, including horses, to wary travelers heading west, or for those seeking gold, and later silver. It was not the lake that drew interest, but the geology of nearby ranges. Yet for many years little really changed in the Tahoe Basin. A few people spent the short summers haying, grazing cattle, operating way stations and saloons, livery stables, and trading posts. The Washoe continued traditional ways of fishing, hunting, and gathering food and materials for the forthcoming winters. And by 1856, the various Sierra gold camps and mining towns that had flourished after 1848 fell into ruin.

Nevada mining proved to be more lucrative, remembered in names such as Gold Hill and faraway Eureka, Nevada. By 1859, the gold rush dominated settlements as miners, speculators, and adventurers flocked to Virginia City, Nevada, in search of easy money. The symbiotic relationship between Virginia City and Lake Tahoe was just beginning. During the next 20 years, the Comstock Lode produced more than $300 million in gold and silver, a precious metallic magnet drawing people and resources from other regions.

Mining, no matter how lucrative, brought problems, as excavating deep fissures was dangerous, difficult, and expensive. Heat and excess water plagued mining activities, and the construction of tunnels designed to supply water to the mines and pump out excess hot water, was behind schedule. Deep-fissure mining required tremendous amounts of timber, and the growth of San Francisco demanded yet more lumber. The historic denuding of Tahoe had begun.

Wealth was exported out of Nevada into San Francisco and California, and timber felled throughout the Tahoe Basin to facilitate that growth, both in mines and cities. At the end of the period of Tahoe's exploitation, what remained was a drastically altered landscape. Most of the old-growth forests were gone, replaced by open hillsides littered with slash and sawdust-choked creeks and rivers. With the exception of the 1899 Lake Tahoe Forest Reserve, and some acreage on the north shore of the lake and around Tallac, Tahoe was virtually denuded. But it was not forgotten.

The age of Tahoe's tourism had now begun. Although most of the early steamers and barges on Lake Tahoe were designed for industrial use, the sight of a boat venturing out onto the vast, deep, blue expanse of Lake Tahoe, surrounded by majestic mountains, was riveting to residents and visitors alike. At the same time, "progress engineers" imagined the railroad as the essential tool in domesticating the Tahoe Basin. Under the 19th century concept of progressivism, the railroad symbolized the triumph of democracy. While Tahoe lumber directly fueled the growth of San Francisco and mining in the Comstock, the railroad also brought into the basin those seeking scenic views, rejuvenating hot spring spas, and domesticated, safe adventures. With the advent of the automobile, the demand to open roads in the Tahoe Basin increased dramatically, and the first "real" road opened in 1913. No longer were excursionists shuttled about in organized fashion; now visitors needed to park cars, and "roughing it," which included fishing, hiking, and horseback riding, became popular. The lake was now within reach of the middle class, opening new markets for Tahoe Basin entrepreneurs. Tahoe's scenic splendor inspired the vernacular— everyday, amateur—use of photography, and taking snapshots became an essential part of the

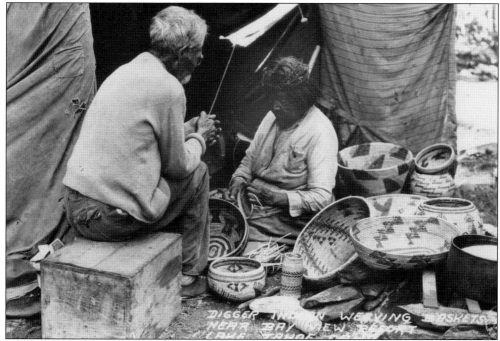

The original caption on this photograph was "Digger Indian weaving baskets near Bay View Resort, Lake Tahoe, Calif." The Euro-American term "Digger," thought to derive from an observed practice of digging for plant roots and tubers, was used to refer to many of the Indian tribes of Nevada and California, often with derogatory intent. This unidentified woman sits in front of a shelter, showing the inclusion of contemporary materials into traditional forms. She is surrounded by an impressive display of Washoe baskets. (Courtesy of the North Lake Tahoe Historical Society.)

experience. One resort even targeted the photographer, calling Lake Tahoe, "seventh heaven for the shutterbug."

After the inevitable decline of the lumber and mining industries, tourism became the main economic engine in the Tahoe Basin. By 1940, fishing was so popular that the lake was stocked with Kokanee and Sebago salmon from the Pacific Northwest. Combined with over fishing, this intrusion contributed to the decline of the native cutthroat trout. Meanwhile, the unlikely merger of gaming and a pervasive "naturalist" economy began to define Lake Tahoe.

Today, major showroom acts and entertainment regularly attract thousands of visitors into what is mundanely called Stateline. Excellent accommodations at reasonable prices fuel the gaming urge of those living in states where gambling is illegal. This corridor, a function of a political boundary, is now a gaming and entertainment mecca. Clearly, the Tahoe Basin is an ideal winter sport environment, and with the 1960s Olympics at Squaw Valley, and an influx of other major recreational activities, including world-class golfing, Lake Tahoe has become an internationally recognized 24-hour resort destination. Visitors have a plethora of choices, from world class skiing, established entertainment gaming, camping, hiking, and all kinds of water sports to the simple luxury of alpine sunbathing and cultural activities such as the annual Shakespeare Festival.

Lake Tahoe's splendid visual history shows a landscape transformed from a plentiful, if not unlimited, natural resource, to a managed wilderness that coexists with skyrocketing real estate, modern architecture, and a gaming amusement park. Although a faceted jewel, its brilliant beauty still shines.

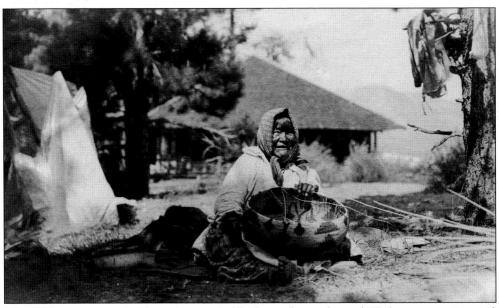

This Washoe woman is holding a large coiled basket with a traditional Washoe geometric motif. Washoe basketry materials included willow, bracken fern, and redbud. Willow provided the light-colored foundation rods and threads. The mud-stained rhizomes of the bracken fern provided a black thread, and fibers from the Redbud tree provided the reddish thread. (Courtesy of the North Lake Tahoe Historical Society.)

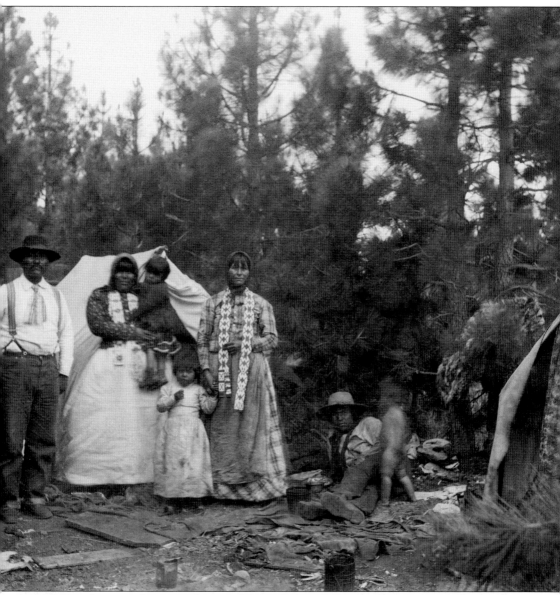

According to the original caption, these are Washoe Indians Billy Merrill, Maggie Merrill, Minnie George, and One-Arm George in a camp at Lake Tahoe. Photographed at the turn of the 20th century, this Washoe family demonstrates how patterns of clothing had already become diffused across cultures. The women are wearing long dresses, aprons, shawls, and head scarves, while the men wear brightly covered shirts and Levis. (Adapted from the Washoe tribal history, *Wa She Shu: A Washoe Tribal History* by Jo Ann Nevers, 1976). The belts the women are wearing around their necks are a type identified by Marvin Cahodas as "bead strips" and are loom woven. (Courtesy of Special Collections, University of Nevada, Reno.)

FURTHER READING

Cahodas, Marvin. *Degikup: Washoe Fancy Basketry 1895–1935.* Vancouver Fine Arts Gallery: The University of British Columbia, 1979.

Dawson, Robert, Peter Goin, and Mary Webb. *A Doubtful River.* Reno: University of Nevada Press, 2000.

Evans, Lisa G. *Lake Tahoe: A Family Guide.* Seattle, Washington: Mountaineers, 1993.

Goin, Peter. *Stopping Time: A Rephotographic Survey of Lake Tahoe.* Essays by Elizabeth Raymond and Robert E. Blesse. Albuquerque: University of New Mexico Press, 1992.

Goin, Peter, ed. *Arid Waters.* Reno: University of Nevada Press, 1992.

Hayden, Mike, edited by Russ Leadabrand. *Guidebook to the Lake Tahoe Country.* Los Angeles: W. Ritchie Press, 1971.

Landauer, Lyndall Baker. *The Mountain Sea: A History of Lake Tahoe.* Honolulu, Hawaii: Flying Cloud Press, c. 1996.

Mark, Leo. *The Machine in the Garden.* London: Oxford University Press, 1964.

Scott, Edward B. *The Saga of Lake Tahoe.* Crystal Bay, Lake Tahoe: Sierra-Tahoe Publishing Company, revised, 1964.

Strong, Douglas H. *Tahoe: An Environmental History.* Lincoln, Nebraska: University of Nebraska Press, 1984.

Twain, Mark. *The Works of Mark Twain: Roughing It.* With an introduction and explanatory notes by Franklin R. Rogers; with text established and textual notes by Paul Baender. Berkeley: University of California Press, 1972.

Wheeler, Sessions S. with William W. Bliss. *Tahoe Heritage: The Bliss Family of Glenbrook, Nevada.* Reno: University of Nevada Press, 1992.

One

SCENICS

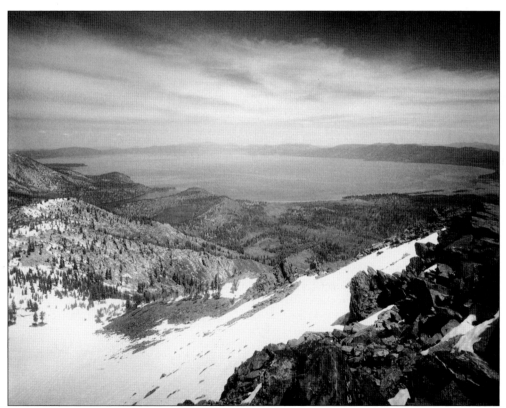

Lake Tahoe, approximately 6,223 feet above sea level, encompasses 193 square miles, measures 21.6 miles long, and at places reaches slightly more than 12 miles wide. Accenting its natural clarity, Lake Tahoe is bordered by Mount Tallac (9,700 feet) to the west; Freel Peak (10,881 feet) to the south; Genoa Peak (9,150 feet) to the east, and Mount Rose (10,778 feet) in the north. Lake Tahoe's depth (1,645 feet) is exceeded by only nine lakes in the world. (Courtesy of the North Lake Tahoe Historical Society.)

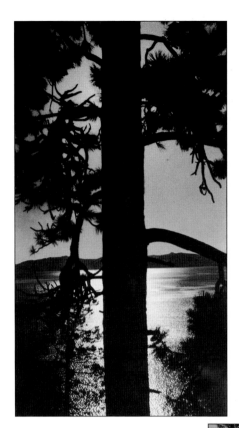

This high-contrast, scenic image was not intended, in any traditional sense, to document the tree or the lake. The composition is an attempt to celebrate the romance of the view. The photographer wanted to portray the intrinsic beauty of a setting sun in an alpine lake environment. Note how the mountains along the horizon become part of the tree, merging the distant landscape with the foreground. (Courtesy of the Nevada Historical Society.)

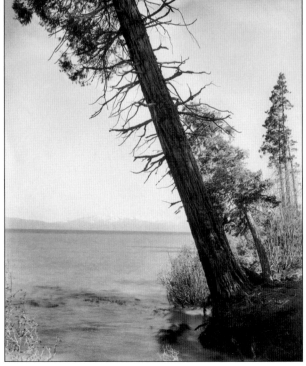

This photograph of a leaning cedar tree employs a dynamic compositional device—that of the diagonal line. Using this active angle, earth, water, and sky are divided differently. Traditionally, landscapes are divided along a horizontal axis. The beauty of the lake provokes many visitors to seek the scenic or picturesque sense of place. (Courtesy of the Nevada Historical Society.)

This photograph focuses on the Glen Alpine Junipers along the Mount Tallac Trail. The enjoyment of the landscape is shaped by the choices photographers make. The experience of the place, of the trail, provokes the desire to record for history the unique views of the sojourn. In this way, the photograph becomes an artifact of the experience itself. (Courtesy of the North Lake Tahoe Historical Society.)

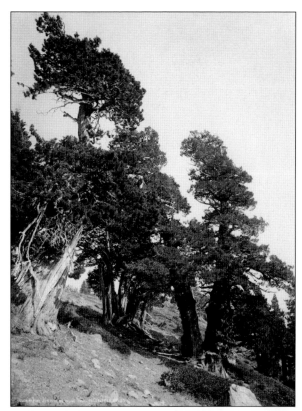

A visitor felt compelled to simply record the clarity of the water and mountain air in this photograph titled, "Scene at North End of Lake Tahoe." There is no specific subject of the photograph, except for the intrinsic "view." This fits a common pattern of vernacular scenic photography. (Courtesy of the Nevada Historical Society.)

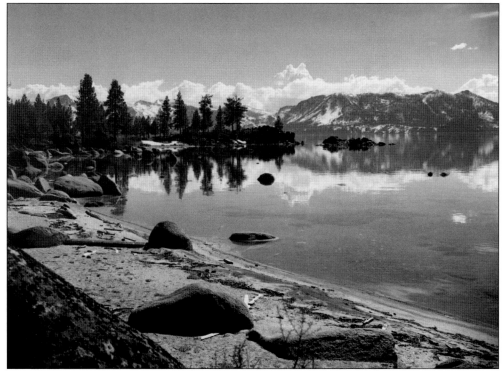

17

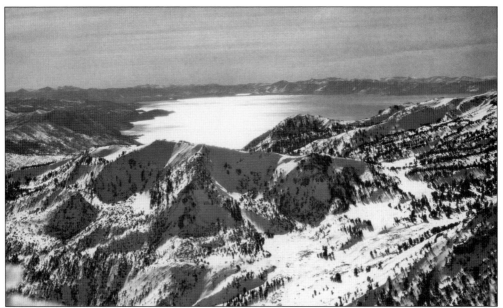

Situated between two crests of the Sierra Nevada at 6,250 feet above sea level, Lake Tahoe is one of the purest and deepest freshwater lakes in North America. More than 70 feeder creeks, streams, and rivers empty into this sparkling jewel. This aerial view offers a clue to the immense volume of water: unleashed, Lake Tahoe would flood the entire state of California 14 inches deep. (Courtesy of the Nevada Historical Society.)

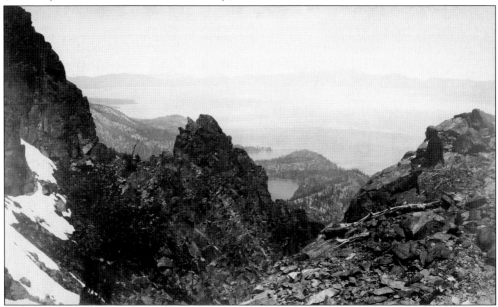

This bird's eye view is from Mount Tallac, a Tahoe landmark that every conscientious tourist should visit. In 1877, Nevada journalist Henry Mighels composed a poem while camping on its slopes: "Oh merciless Tallac,/After many a thump and whack./I'm astride your rugged back,/ And I am blue and black,/And limp as any sack./And yet I'm in the tract/Of a most infernal pack,/Of mosquitoes who attack/My neck about the back ." (Courtesy of the South Lake Tahoe Historical Society.)

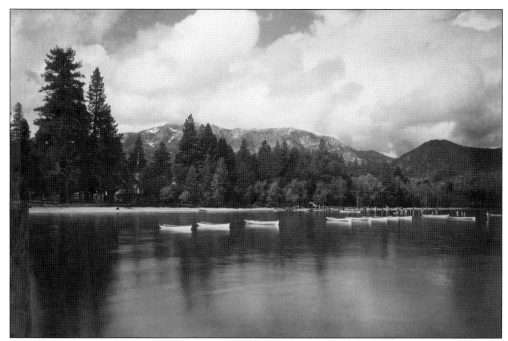

This is a distant view of Mount Tallac from Lake Tahoe. Tallac is considered the most famous peak in the Tahoe region, in part due to the cross of snow that forms high on the northeastern slope in the spring and summer each year. According to some accounts, *Tellec* was a native Washoe word meaning "great mountain," but the definitive source is undetermined. (Courtesy of the Nevada Historical Society.)

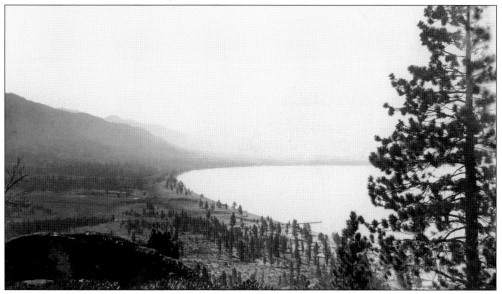

"Sapphire Bay," as this was originally captioned, was better known as Boundary Bay, where fishermen in Tahoe's early days spread seine nets along the shoreline, catching thousands of native silverside and cutthroat trout from the sandy shallows. But aesthetics, rather than industry, is the subject here. Emerald Bay State Park is at the far distance. Baldwin, Kiva, and Pope beaches make this a popular area. (Courtesy of the South Lake Tahoe Historical Society.)

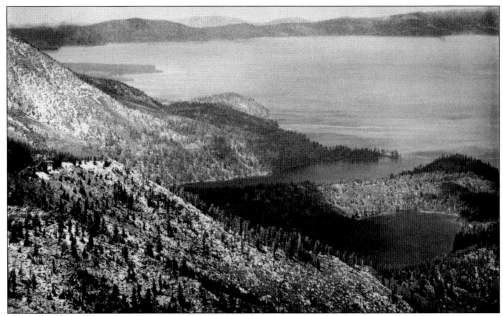

The scale and size of Lake Tahoe is often difficult to discern unless it is viewed from above, as this example clearly demonstrates. In the foreground of this 1934 image, Cascade Lake and then Emerald Bay are evident. (Courtesy of the North Lake Tahoe Historical Society.)

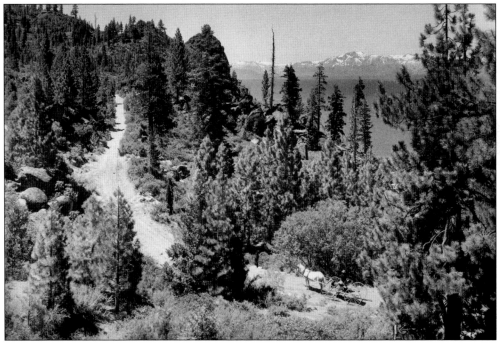

The Tahoe alpine experience is sufficiently invigorating that travelers often feel compelled to stop along the road and gaze at the view. Hiking up a nearby hill, this photographer recorded the grand vista, road, horse, passenger, and carriage, a common documentary strategy even in contemporary landscape photography. The unidentified individual waiting below provides scale more than anything else. (Courtesy of the North Lake Tahoe Historical Society.)

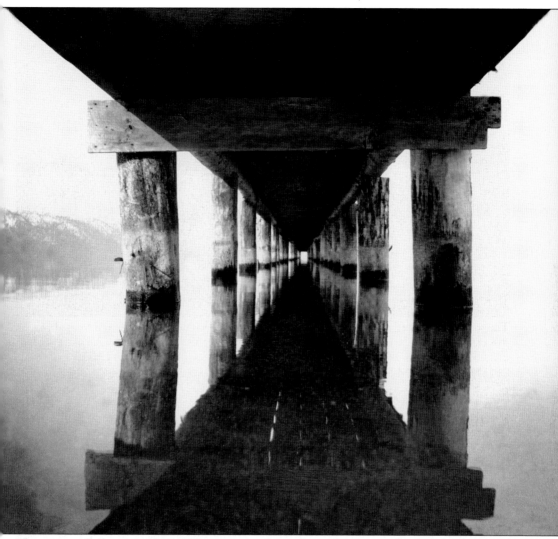

The spectacular beauty of Lake Tahoe's environment elicits almost any photographer's sense of composition. Harmony in a photograph is best achieved through the graceful representation of form, balance, and order. This view looking down an unidentified pier indicates that the photographer was more interested in the abstract and compositional qualities of the reflections and geometry than in the history of the site itself. (Courtesy of the South Lake Tahoe Historical Society.)

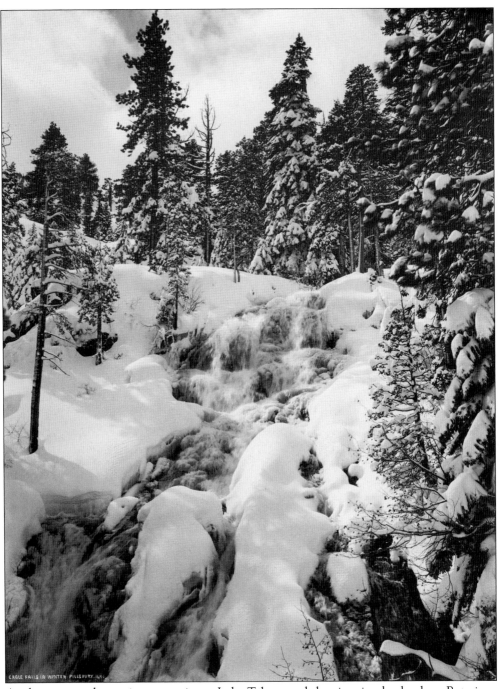

EAGLE FALLS IN WINTER PILLSBURY, ILL.

As the seasons change in mountainous Lake Tahoe, each has its visual splendors. But given that black-and-white photography prevailed until the mid-20th century, winter offers some of the more spectacular imagery. In this view of Eagle Falls, a requisite icon of alpine beauty, the landscape is covered with the white velvet of new snow. (Courtesy of the North Lake Tahoe Historical Society.)

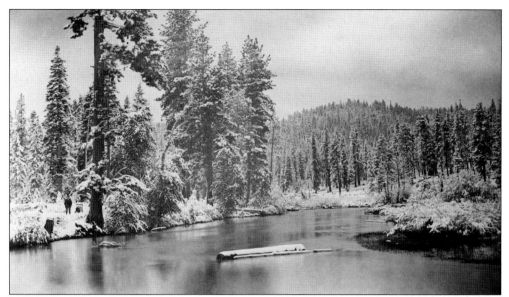

R. J. Waters was one of the earliest, most prolific, and skilled photographers working in and around Lake Tahoe. While he often made industrial views, he also appreciated the spectacle of the Truckee River in winter, near Lake Tahoe, c. 1886. (Photograph by R. J. Waters; courtesy of Special Collections, University of Nevada, Reno.)

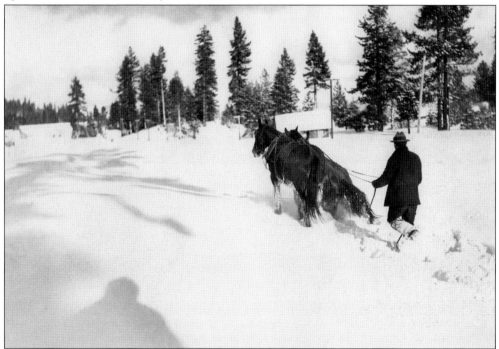

Snowcapped mountain peaks are essential to winter scenes, but vernacular views are more often focused on the overwhelming volume of snow. Tahoe City roads were not plowed in the winter, so horses, skis, or snow shoes were the land transportation until the late 1930s. The shadow of the photographer is in the bottom left corner. (C. W. Vernon Collection, courtesy of the North Lake Tahoe Historical Society.)

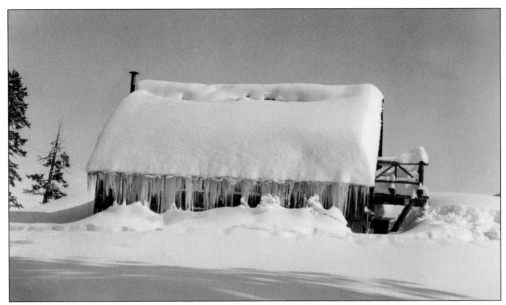

This snow appears luminescent in the thin, brisk mountain air at Adolph Ehrborn's Echo Summit (7,377 feet). Nearby Echo Peak was named by the Wheeler Survey in 1877 and is located directly north of Upper Echo Lake, northwest of Flagpole Peak (8,363 feet). Echo Summit was formerly known as Nevett's Summit, and before that as Johnson's Pass. (Courtesy of the South Lake Tahoe Historical Society.)

Only a vague outline of the building remains after a particularly heavy snowfall in February 1932. This is a photograph of the Young cabin. (Courtesy of the South Lake Tahoe Historical Society.)

Seasonal snowfall, especially when it is heavy, appears to call for documentation. The bright sun flares off the lens of the camera, upper left, picturing the Tahoe Tavern covered in snow. (Courtesy of the South Lake Tahoe Historical Society.)

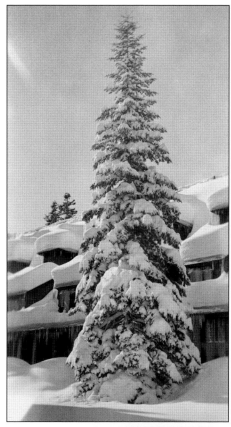

In this case, all that is visible under the heavy snow is the diamond stack of the train engine, at center. (Courtesy of Special Collections, University of Nevada, Reno.)

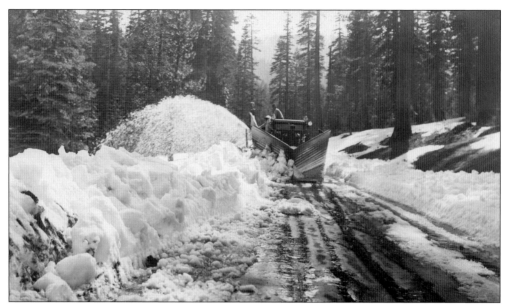

This photograph shows one of the early snowplows clearing Highway 50 in the winter of 1934. (Courtesy of the South Lake Tahoe Historical Society.)

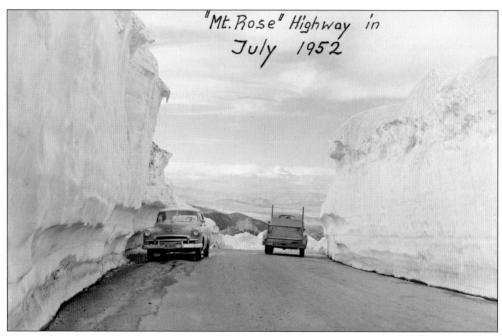

This postcard view clearly demonstrates the potential for tremendous snowfall in the Tahoe Basin. This is the summit along the Mount Rose highway in July 1952. The depth of the snow is so overwhelming that it needs a photograph just to be believed. The automobiles provide a convenient sense of scale. (Courtesy of the North Lake Tahoe Historical Society.)

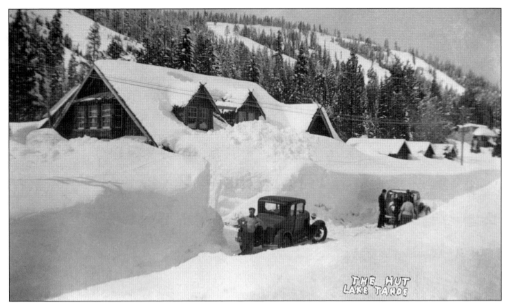

There is so much snow on the ground, that a photograph must be made! Consistent with vernacular photographic style, this image demonstrates the scale of the snowfall as it dwarfs the cars. A man poses along the back of the car, at center. The caption reads, "The Hut, Lake Tahoe." (Courtesy of the South Lake Tahoe Historical Society.)

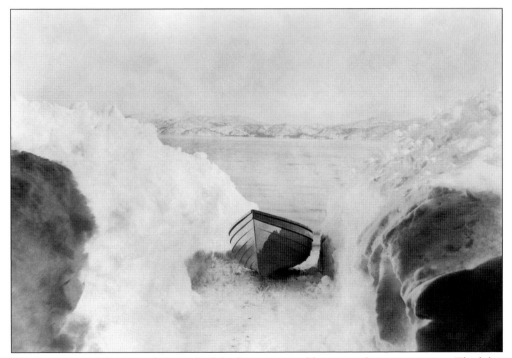

The heavy snowfall pictured along the lakeshore appears like waves, frozen in motion. The lake, beyond the boat, adds to the mystery of the image as it contributes to the illusion. (Courtesy of Special Collections, University of Nevada, Reno.)

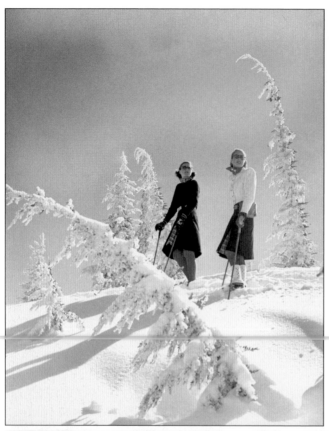

The angle of the photographer's viewpoint—raised, toward the sky—monumentalizes Mary Thorp and friend, spectators observing the spring races at the Sugar Bowl Ski Resort. This documents an outing on a beautiful, wintry day, so typical of the entire Lake Tahoe experience and landscape. (Courtesy of the South Lake Tahoe Historical Society.)

This hail stone pile is probably the result of inclement summer weather, but the Camp Chonokis staff neatly swept this mound up for the photographer. An onlooker's shadow is leaning in from the left. (Courtesy of the South Lake Tahoe Historical Society.)

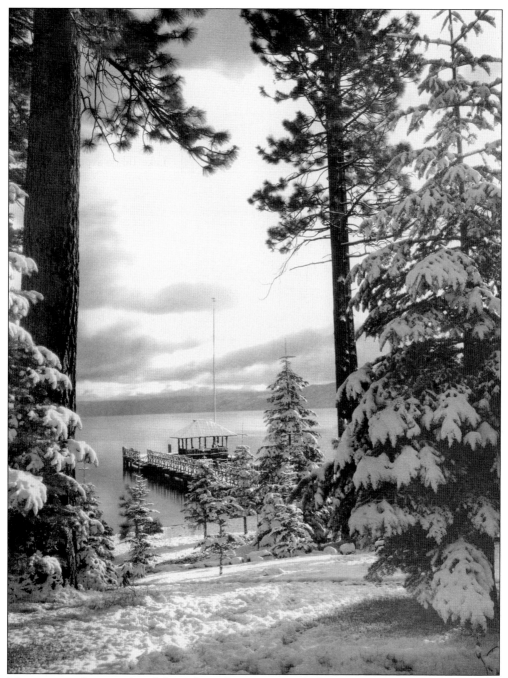

Most scenic photographs of the Lake Tahoe region include, however obliquely, an image of the lake itself. In this photograph, the majestic pines frame the pier emerging beyond the water's edge, making Tahoe a land of a thousand views. (Courtesy of the North Lake Tahoe Historical Society.)

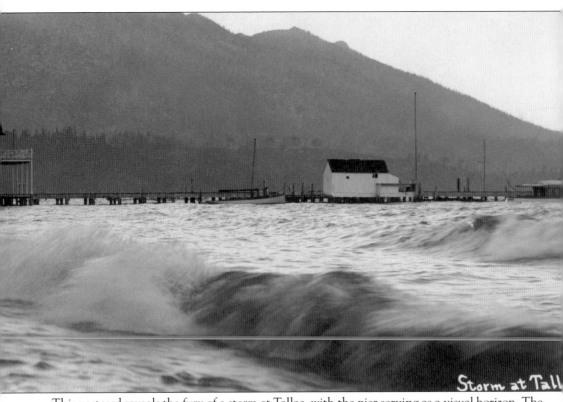

Storm at Tall

This postcard reveals the fury of a storm at Tallac, with the pier serving as a visual horizon. The view is more about the size of the waves than the scene itself. Anecdotal accounts of Lake Tahoe's weather are many. Edward B. Scott in *The Saga of Lake Tahoe* writes about wind that blows from all points of the compass at one time, and that because Tahoe's waters become agitated so suddenly, residents in the 1870s thought that gigantic subterranean geysers influenced the surface flow of wind and wave. (Courtesy of Special Collections, University of Nevada, Reno.)

Two

LAKES

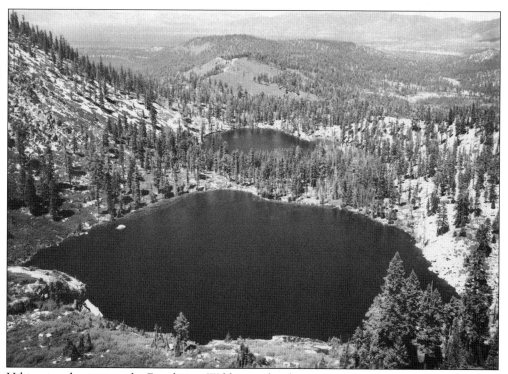

Hiking in what is now the Desolation Wilderness has been a popular activity, written about in the earliest accounts of the Tahoe Basin. Mark Twain, simply in pursuit of the majestic aerial view, wrote about it in *Roughing It,* describing the ascent and descent of different mountains in the Sierra Nevada. The Desolation Wilderness was originally part of the Lake Tahoe Forest Reserve, established in 1899. In 1910, when the first tourists were beginning to make their way over the narrow dirt roads of Echo and Donner summits, the area was made part of the newly formed Eldorado National Forest. Although within the national forest, these Angora Lakes are just outside the formal boundary of the wilderness area. (Courtesy of the North Lake Tahoe Historical Society.)

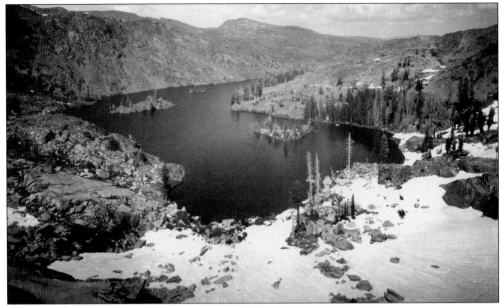

This area of the Sierra Nevada, mostly dramatic sub-alpine and alpine forest, granite peaks, and glacially formed valleys and lakes, is a magnet for outdoor enthusiasts. Angora Peak (8,588 feet) and Echo Peak (8,895 feet) provide a spectacular backdrop for hiking, camping, and exploring. This 1962 view is listed as "Upper Lake with snow in foreground." (Courtesy of the North Lake Tahoe Historical Society.)

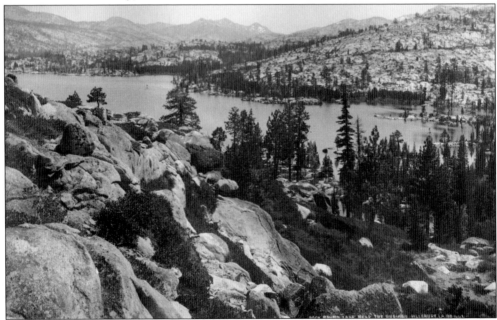

Rockbound Lake (near the Rubicon, according to the caption on the image) is on the far northwestern edge of the Desolation Wilderness. Its waters drain into Buck Island Lake, part of a larger water management system. Many contemporary accounts of hiking, particularly here and along the Rubicon Trail, emphasize the overwhelming number of mosquitoes. (Courtesy of the North Lake Tahoe Historical Society.)

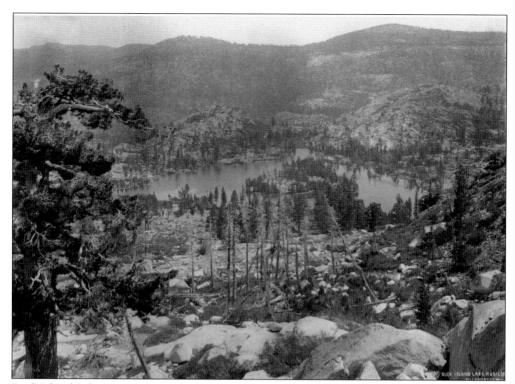

Buck Island Lake rests just outside the Desolation Wilderness, south of the Rubicon River. This lake is along the Rubicon Trail, the most famous and difficult four-wheel-drive trail in the world. For the average motorist, this trail is impassable. Most travelers recommend a one-night rest at Buck Island Lake. The Jeepers Jamboree closes down the trail one weekend a year. (Courtesy of the North Lake Tahoe Historical Society.)

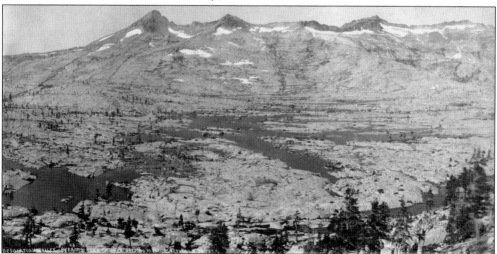

This view of Desolation Valley looks in a southerly direction towards Pyramid Peak (9,983 feet) in the Crystal Range. This grand view shows the glacial character of this granite high country. The area surrounding Lake Aloha was named the Desolation Valley Primitive Area in 1931. In 1969, Desolation Wilderness was recognized by Congress and included in the National Wilderness Preservation System. (Courtesy of the North Lake Tahoe Historical Society.)

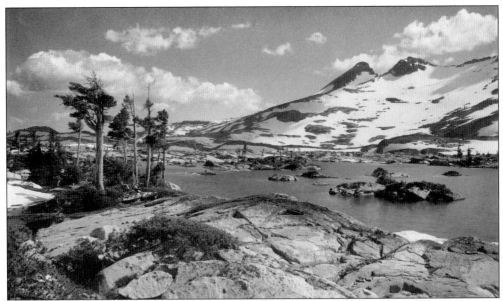

Lake Aloha, at an elevation of approximately 8,116 feet, was originally a chain of tarns (small mountain lakes) before it was impounded by a dam. Despite the fact that you're surrounded by Pyramid Peak (9,983 feet), Ralston Peak (9,235 feet), and Jacks Peak (9,856 feet), you're actually at the crest of the Sierra Nevada, which runs along the dam. Water flowing east winds up in Lake Tahoe; water flowing west heads towards the Pacific Ocean. (Courtesy of the North Lake Tahoe Historical Society.)

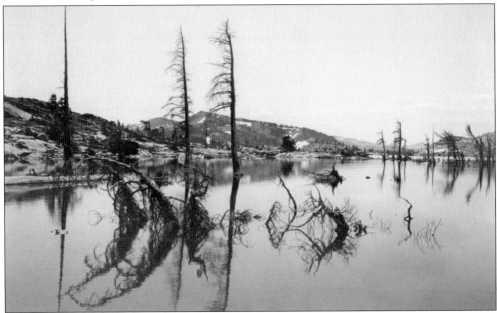

This eloquent photograph was made by an unidentified hiker from Camp Chonokis on an excursion into Desolation Valley. Remnants of the winter's snow remain in the distance, and the hiker was obviously struck by the beauty and graphic quality of the trees and their reflections in the still water of the lake. The photograph was made in 1932. (Courtesy of Special Collections, University of Nevada, Reno.)

34

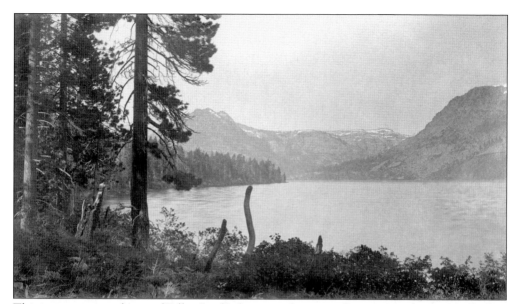

This is a very unusual view of Fallen Leaf Lake, at an elevation of approximately 6,375 feet, taken c. 1886. Note how the shape of the trunk in the foreground appears lifelike, and how it seems to support the point of land off in the distance. (Photograph by R. J. Waters; courtesy of Special Collections, University of Nevada, Reno.)

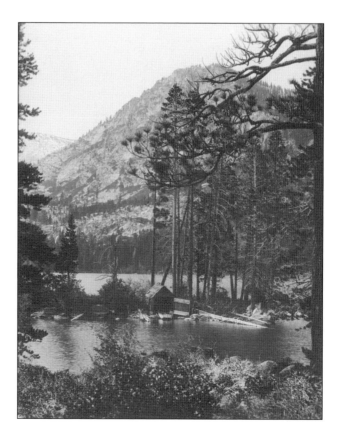

This is an early view of a small boat and shed, trees with lake, and mountains at either Fallen Leaf or Cascade Lake. Fallen Leaf Lake, consistently popular with hikers and campers, is now dotted with summer cabins that still retain a remote, mountain feeling. Fallen Leaf Lake is the stepping-off point to the Desolation Wilderness. Cascade Lake is more private, as access is limited. (Courtesy of the South Lake Tahoe Historical Society.)

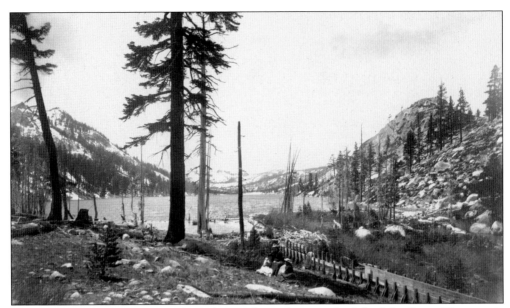

These "three school marms at Echo Lake" are located just to the left of the flume. The view is looking west toward Desolation Valley, Pyramid Peak, and the Crystal Range. Talking Mountain (8,824 feet) is to the left and Flagpole Peak (8,363 feet) to the right. The Tahoe-Yosemite Trail from Lower Echo Lake affords the easiest hike into the Desolation Wilderness. (Courtesy of the South Lake Tahoe Historical Society.)

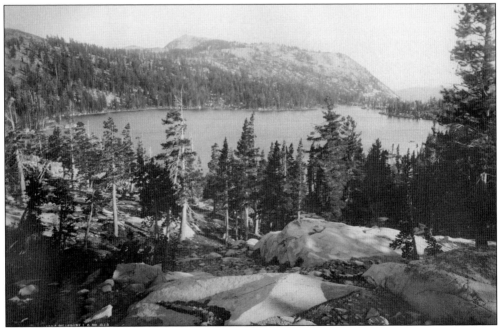

Lake of the Woods is part of a chain of glacial lakes including Fallen Leaf Lake, the Echo group of lakes, Cascade Lake, Tamarack, and more than 20 other smaller lakes within the Desolation Wilderness. Both Ralston Peak (9,235 feet) and Pyramid Peak (9,983 feet) frame all of these lakes, creating a spectacular scenic environment. (Courtesy of the North Lake Tahoe Historical Society.)

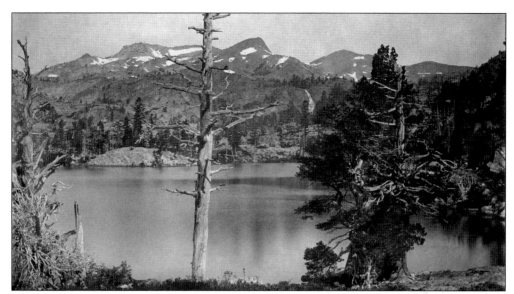

This photograph of Grass Lake references this site as "Gilmore's Glen." Grass Lake is part of the watershed for Fallen Leaf Lake. Nathan Gilmore was a young rancher who drove cattle to the West in 1849 to the south shore of Fallen Leaf Lake. While tracking stray stock one night, Gilmore discovered the spectacular beauty of what is now called Desolation Wilderness. (Photograph by R. J. Waters; courtesy of Special Collections, University of Nevada, Reno.)

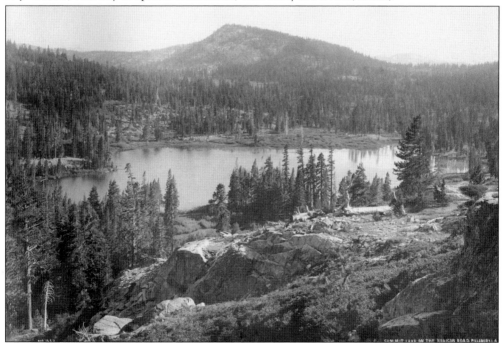

This is a view of Summit Lake on the Rubicon Road. Also known as Spooner Lake, it served a role in the early logging days of Lake Tahoe. By 1870, the Summit Fluming Company controlled 1,840 acres at Spooner Summit in addition to all of Summit Lake. Michel Spooner operated a ranch and station at the summit for more than twenty years until he went bankrupt. (Courtesy of the North Lake Tahoe Historical Society.)

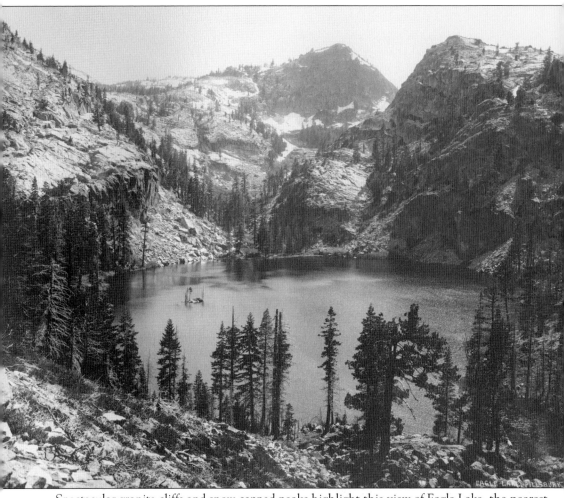

Spectacular granite cliffs and snow-capped peaks highlight this view of Eagle Lake, the nearest alpine lake above Emerald Bay. Its waters directly feed Eagle Falls, the most popular waterfall in all of Lake Tahoe. There are three successive waterfalls, each more than 75 feet high. (Courtesy of the North Lake Tahoe Historical Society.)

Three

TRANSPORTATION AND INDUSTRY

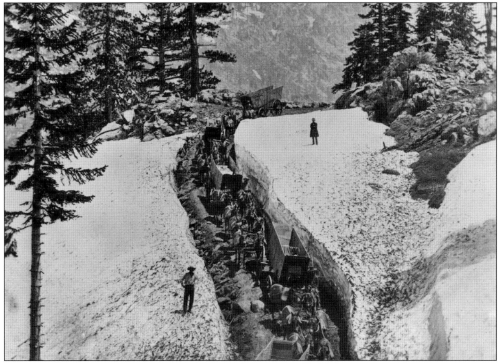

This photograph, made in June of 1865, clearly demonstrates the heavy volume of snow common throughout the Sierra Nevada. The deep snows made traveling and hauling freight, critical to the development of the Tahoe Basin, time consuming, dangerous, and arduous. The roadway, such as it was, had to be cleared without benefit of machinery. These empty wagons are headed to Strawberry Station, a favorite teamster stop in the early 1860s. (Photograph by R. J. Waters; courtesy of Special Collections, University of Nevada, Reno.)

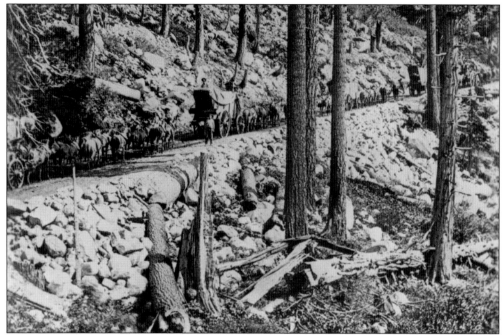

These two *c.* 1886 photographs show a freight train's springtime journey into the Tahoe Basin. Given the relatively slow film speeds of the era, it was necessary to halt the action, requiring a directorial approach. In the view above, individuals are quite small in the grand scheme of the image's composition and are not identified. Yet just about every person stopped and posed for the camera. Below, wagons stop at a way station near Glenbrook. Note that the wagon closest to the bottom of the photograph identifies "Lake Bigler." Often separated, this series by one photographer employs a documentary approach to mark the passage of the freight train into the Tahoe Basin. (Photographs by R. J. Waters; courtesy of Special Collections, University of Nevada, Reno.)

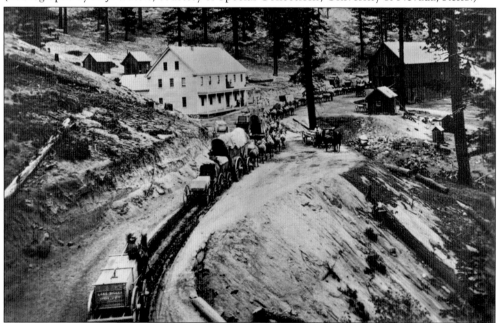

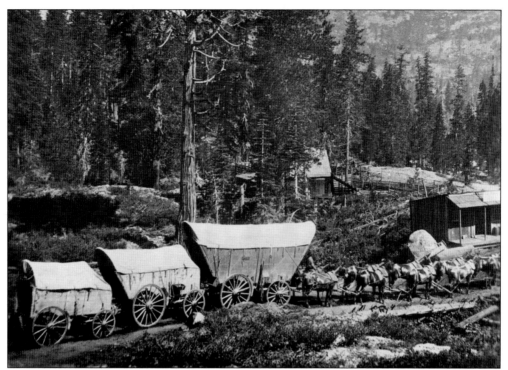

The historical caption on this photograph specifies a date range between 1860 and 1869. It offers a close-up view of the wagons, revealing that the only person in the photograph is the man holding the horses steady, a pose presumably intended to avoid blurring the image. (Photograph by R. J. Waters; courtesy of Special Collections, University of Nevada, Reno.)

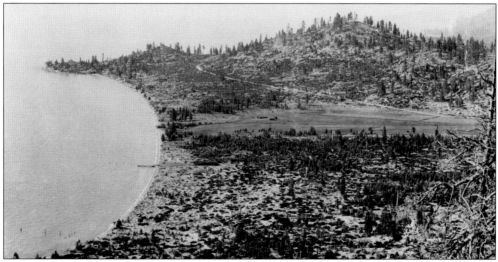

Marla Bay is just south of Zephyr Cove and north of Roundhill on the west side of Lake Tahoe. In the spring of 1864, John Marley, a native of England, claimed 160 acres surrounding the bay. There he raised hay and planted potatoes and other vegetables, selling them to travelers passing along the Lake Bigler Toll Road. The area was selectively logged, leaving the stunted growth for cordwood cutting. Though not verified, the photograph is credited to William Conn. (Courtesy of the Nevada Historical Society.)

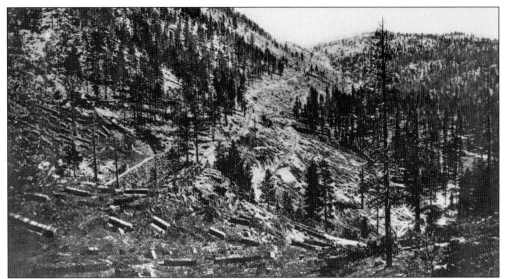

During 28 years of logging activity, more than 750 million board feet of lumber and 500,000 cords of wood were harvested, essentially denuding the Tahoe Basin. Today the vast majority of the basin's trees are of uniform size because they are second- or third-generation growth, following the logging of most of the virgin forests in the late 19th and early 20th centuries. Pine and fir trees constitute the bulk of the forests throughout the basin today. (Courtesy of the South Lake Tahoe Historical Society.)

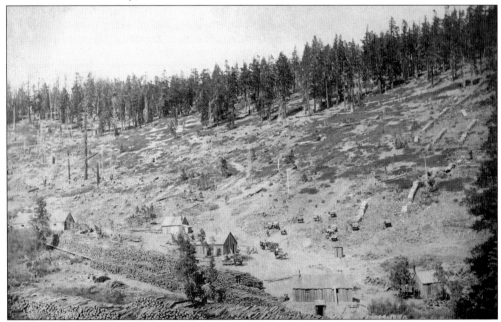

Many general views of Lake Tahoe's mountains covered in pine, fir, and cedar offered the appearance of an unlimited supply of lumber. Within the Comstock mines, straight, heavy timbers nearly 20 feet long and 12 inches square were interlocked in frames built against walls, placed side by side, or on top of one another to any height necessary, making the Comstock a voracious consumer of Tahoe's timber. This view is of Spooner summit camp. (Courtesy of the Nevada Historical Society.)

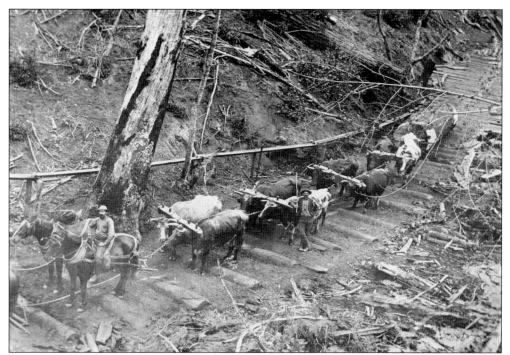

Part of the historical imperative is to document, via portraiture, the processes and participants in industry and commerce. Note that this is a portrait of both the men and the oxen team, dragging a single, enormous log to a mill. The photograph is attributed to a period in the 1890s. Usually, oxen were thought to be too slow, and horses too prone to injury for hauling logs up the grueling grades. (Courtesy of the Nevada Historical Society.)

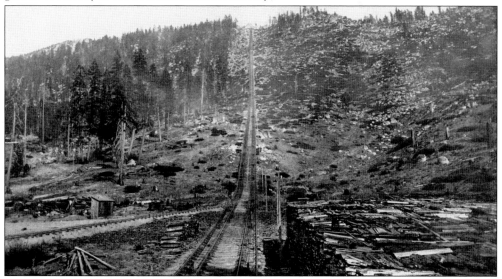

Considering the difficulty of carrying logs over rough, steep roads, the Sierra Nevada Wood and Lumber Company built this double-track, narrow-gauge tramline, 18 feet wide, 4,000 feet long, with a vertical lift of 1,400 feet. It was engineered by Capt. John Bear Overton to run straight up the side of the mountain east of the mill, hence the name, Incline Tramway. This photograph was made in 1885. (Courtesy of the Nevada Historical Society.)

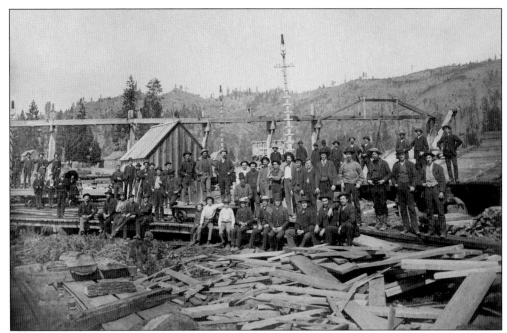

Although individual names are not recorded, this group portrait reveals a proud view of the basin's industry. Note that the photographer prefaced the view with a "display" of lumber in the foreground, indicating the nature of the industry. Note the gentlemen at far left as they extend their right arms on the shoulder of the next man, in unison. (Courtesy of Special Collections, University of Nevada, Reno.)

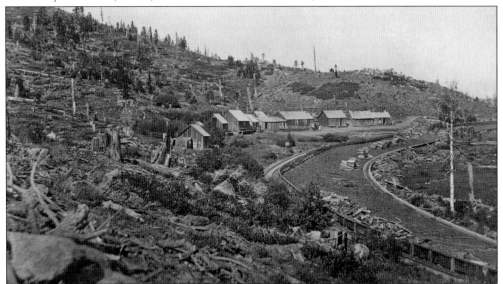

Summit Camp (originally named Eagle Valley Pass) was a primary station for moving lumber out of the Tahoe Basin. The cordwood feeder flume, capable of handling 750 cords of wood per day, is visible at right. At center right, lumber and cordwood from the shores of the lake are unloaded from Lake Tahoe Railroad cars to begin the 12-mile, V-flume trip down Clear Creek to Carson Valley. (Photograph by C. E. Peterson; courtesy of Special Collections, University of Nevada, Reno.)

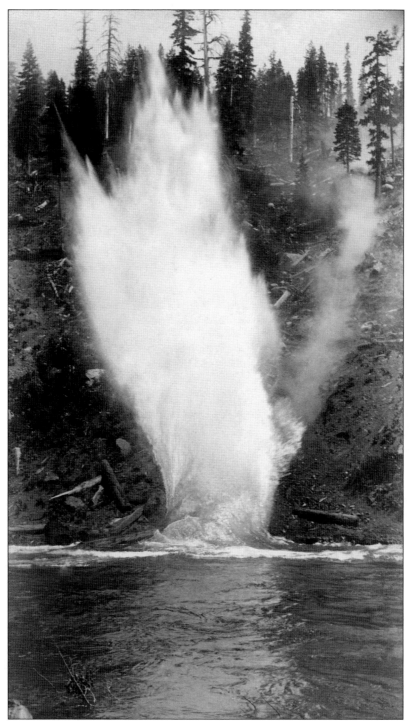

One of the more spectacular photographs of the logging era is this *c.* 1886 action view of a log making a dramatic splash in the Truckee River. Note the water trail indicating the route of the log chute. (Photograph by R. J. Waters; courtesy of Special Collections, University of Nevada, Reno.)

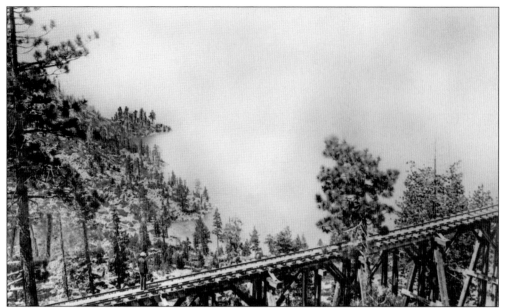

By the spring of 1864, almost all of Tahoe's eastern shore was experiencing an insatiable demand for wood, especially for use in the Comstock mines. Flumes, log chutes, and logging roads reached farther and farther into the heavy timber stands, and the landscape offered an industrial view. Elevated tracks divide the landscape, visually and figuratively. (Perriott Collection; courtesy of the South Lake Tahoe Historical Society.)

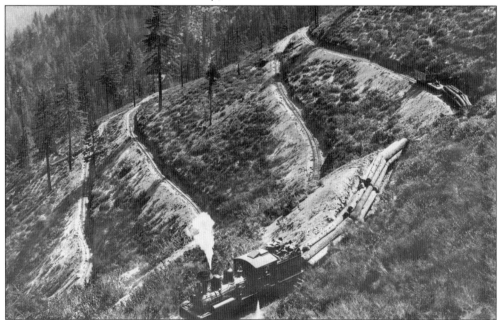

Early industrial development in the Tahoe Basin involved harvesting trees, hence the importance of the railroad. Note the steep switchbacks, and imagine how difficult it would be to use stock animals to carry the enormous weight of thick logs up the steep incline. Steam-powered engines were the first to economize the process. (Hinsey Collection; courtesy of the South Lake Tahoe Historical Society.)

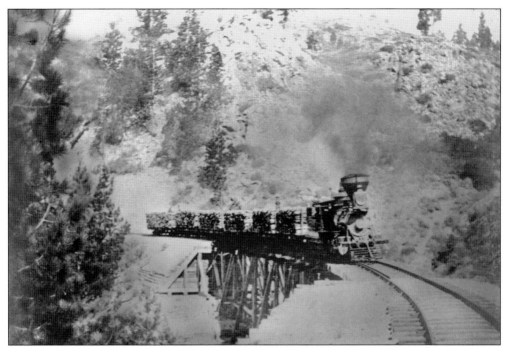

Baldwin Locomotive Works supplied the first two engines for the Lake Tahoe Railroad. Although small, these were powerful locomotives, weighing 10 tons each and equipped with diamond smokestacks. An iron cowcatcher was attached in front, and above were square oil-burning headlights. Each engine could pull 70 tons of lumber or cordwood at a maximum speed of 10 miles per hour. One locomotive could pull six cars stacked with 36 cords of wood. (Courtesy of the South Lake Tahoe Historical Society.)

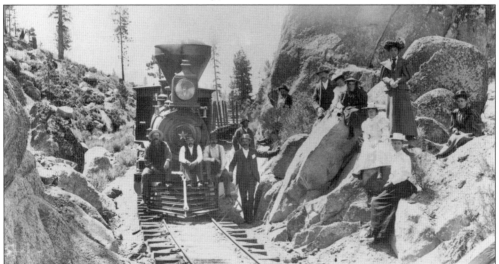

The image of the locomotive had become a pervasive symbol of progress, of taming a savage land. The fallow landscape was to become a regenerated one, proving man's productivity, wealth, and power. The introduction of the machine into the "garden" was a point of pride, as evidenced by these people, posing in their Sunday best with the engine. (Photograph by Bommarito; courtesy of the Nevada Historical Society.)

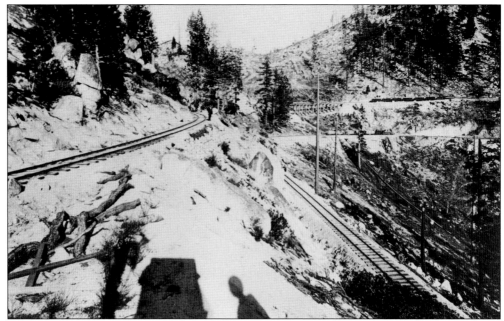

The shadow of famous photographer Carleton Watkins is recorded here along with the switchback at the upper end of Pray Meadows, c. 1878. Included in the eight and three-quarter miles of road were 10 trestles and a 270-foot tunnel. Initial work started on this section in 1874. Once completed, the terminus of the railroad was 910 feet above the lake, with a total rise of 105 feet per mile, an engineering achievement at the time. (Courtesy of the Nevada Historical Society.)

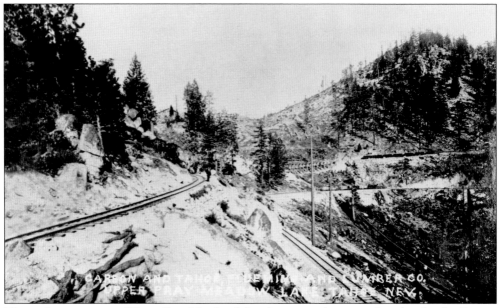

This is the same image, "Upper Pray Meadow," dated two years later, now listed under the Carson and Tahoe Fluming and Lumber Company name. Watkins's shadow has been cropped and text added. The Carson and Tahoe Lumber and Flume Company moved into Glenbrook in the spring of 1873 when it purchased five and a half acres of lakeshore and meadowland property from Augustus W. Pray. (Courtesy of the South Lake Tahoe Historical Society.)

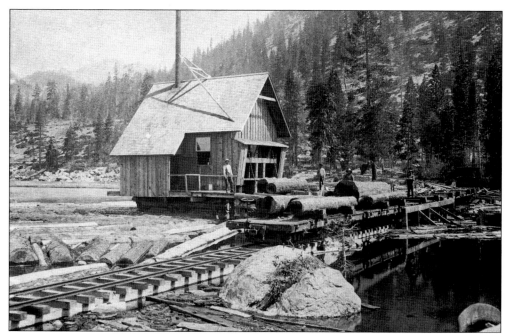

Moving logs to the mill required railroads, barges, and steamers. In this view at Sand Harbor, logs accumulated in ponds and traveled via barges to Incline. Boats and barges became major carriers of shingles and cordwood across the lake, but they could not carry large logs. These were deposited in the lake and gathered into log booms, towed by steam barges to Glenbrook, closest setting-off point for the Comstock mines in Virginia City. (Courtesy of the Nevada Historical Society.)

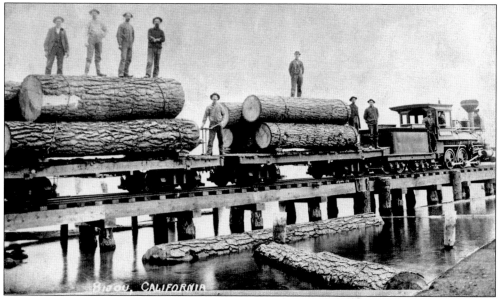

The 10-ton Mogul locomotive named *Santa Cruz* rests on the 1,800-foot-long Bijou pier, staging area for log booms, while a portrait of workers is made. The *Santa Cruz* was purchased specifically for logging and equipped to maintain a 12-mile speed limit while pulling a full load. This view focuses more on industry, scale, and progress than on workers. (Courtesy of the South Lake Tahoe Historical Society.)

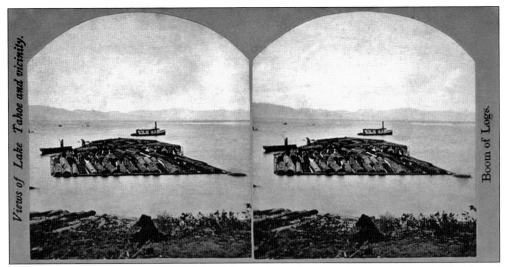

This is a stereograph, a common turn-of-the-century photograph intended to add depth and realism. The overwhelming success of the stereo viewer and subscription views contributed to the rise of tourism nearly everywhere, as people began to discover natural wonders inexpensively in their parlors. This view shows a "Boom of Logs" towed by one of Tahoe's steamers. The dog in the foreground adds the separation necessary to accomplish the 3-D quality of the image. (Courtesy of Special Collections, University of Nevada, Reno.)

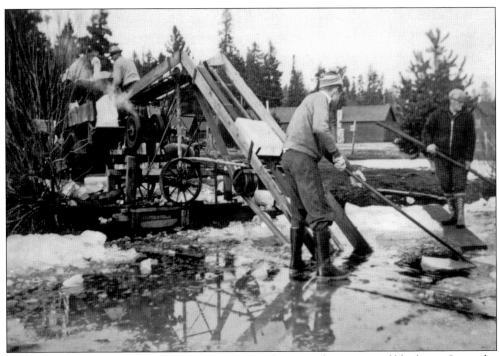

A common yet often neglected industry at Lake Tahoe was the cutting of block ice. Since the waters of Lake Tahoe rarely freeze, it might be surprising to discover this industry at Meeks Bay. This photograph made in 1929 shows the operation with Charlie Heller, caretaker. (Courtesy of Special Collections, University of Nevada, Reno.)

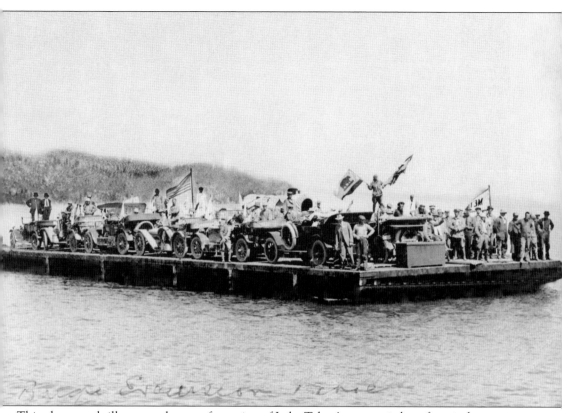

This photograph illustrates the transformation of Lake Tahoe's economic base from industry to tourism. No longer hauling log booms, this barge now conducts excursions for motorists. The passengers and vehicles on board show a wide range of technology, from the covered wagon in the background (near the middle of the photograph), to a variety of automobiles and well-dressed gentlemen. Only one woman is visible, and she is difficult to find. Note the steamship *Meteor's* flag, the California state flag, and the American flag. (Courtesy of the South Lake Tahoe Historical Society.)

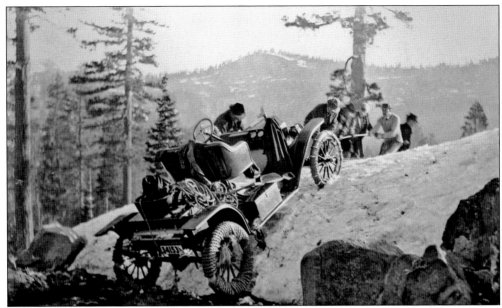

The automobile came to Tahoe *c.* 1910 with a big supply of spare tires, chains, block and tackle, and rope. Roads were either primitive or nonexistent. It always helped to bring along four or five friends to help pull the automobile over banks of snow. By 1935, when the summer roads opened around the lake, the automobile had just about entirely replaced the steamships for transportation, shipping, and mail. (Courtesy of the North Lake Tahoe Historical Society.)

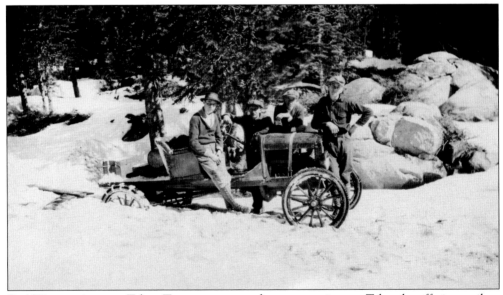

By 1911, proprietors at Tahoe Tavern encouraged auto excursions to Tahoe by offering a silver cup to the first car over the pass each season. This winter view shows four men with their pride and joy, a 1917 Model T stuck, unfortunately, in the snow. Note the wooden planks at the rear of the vehicle and its deeply sunk rear tires. (Mark Terrault Collection, courtesy of the South Lake Tahoe Historical Society.)

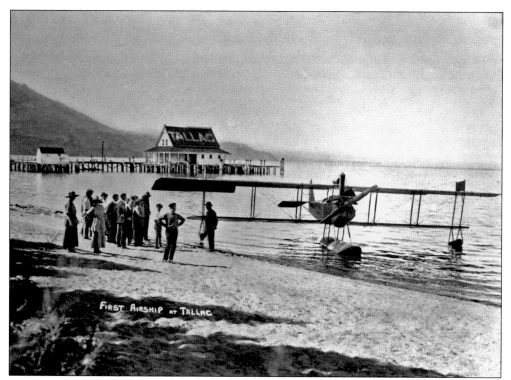

This is a historic view of the first airship that landed at Tallac. It is interesting that the first airplane to land at Lake Tahoe was a seaplane. However, most seaplanes avoided the lake due to unpredictable weather. Note the group of people at left examining this novel curiosity. (Courtesy of the South Lake Tahoe Historical Society.)

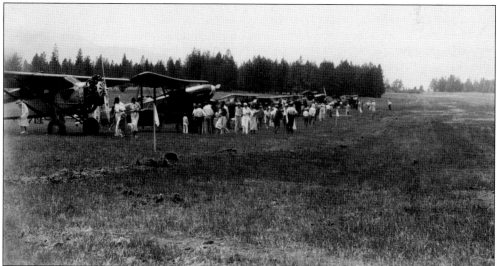

The first standard airplane arrived and departed from the basin at the site that would become Harvey's Wagon Wheel in South Lake Tahoe. Causing quite a flurry of anticipation, the event was successfully and safely completed in 1933. This site later became the South Lake Tahoe Airport. Even to this day, air travel into the Tahoe Basin requires tremendous care due to unpredictable updrafts. (C. W. Vernon Collection, courtesy of the North Lake Tahoe Historical Society.)

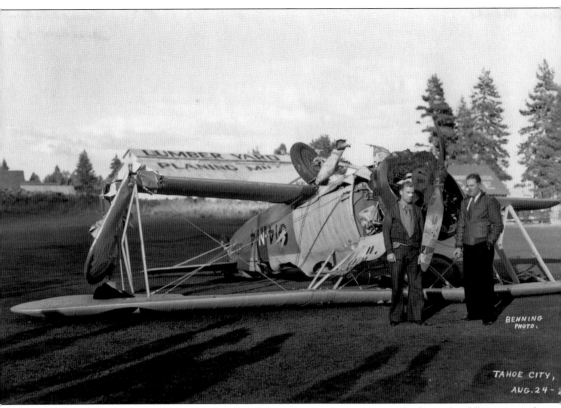

This photograph, made on August 24, 1935, obviously demonstrates the hazards of flying into the Tahoe Basin. Note that both men appear to have bandages on their faces, presumably from the mishap. The shadows of many onlookers are visible in the foreground. (Photograph by Benning; courtesy of the North Lake Tahoe Historical Society.)

Four

STEAMERS

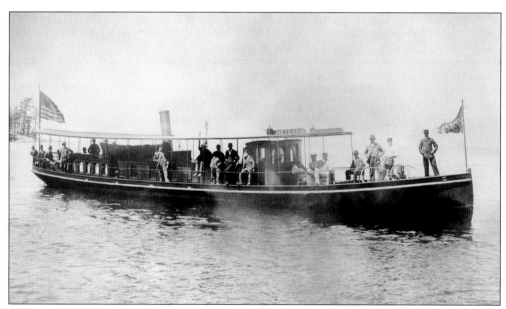

The steamship *Meteor*, the first iron-hulled ship on Lake Tahoe, was launched on August 27, 1876. This is a technical date, however, as its first complete trial run occurred a bit later on September 15, 1876, when the *Meteor* reached a speed of 19 ½ knots. From 1876 to 1896, *Meteor* towed thousands of log booms from Bijou, Emerald Bay, Lonely Gulch, Meeks Bay, Sugar Pine Point, Observatory Point, and Carnelian Bay to mills in the Glenbrook area. After this brief industrial period, *Meteor* continued as a commercial passenger boat during the summer and a mail carrier during the winter. The *Meteor's* superstructure consisted of an enclosed pilothouse, engine room with crew and passenger quarters, and 15 feet of open decking. The photograph was made between 1876 and 1896. (Courtesy of Special Collections, University of Nevada, Reno.)

This is another view of the steamship *Meteor*. Duane L. Bliss had the 80-foot-long hull built in Wilmington, Delaware, shipped by railroad to Carson City, and then hauled by mule and ox team to Glenbrook. Note the kerosene-burning searchlight, similar to those on Tahoe's early locomotives, mounted on top of the wheelhouse. The *Meteor* was then the fastest inland steamer in the world, as well as the fastest boat on the Pacific Coast. (Courtesy of the South Lake Tahoe Historical Society.)

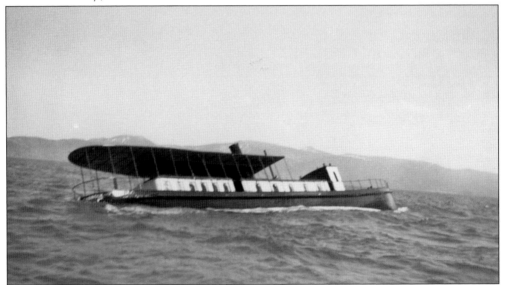

Meteor was in service an unusually long time—more than 60 years. It was on April 21, 1939, that *Meteor* was towed by the steamship *Gypsy*, halfway between Tahoe City and Glenbrook, and sunk. According to Edward B. Scott in *The Saga of Lake Tahoe*, a cold wind blew out of the south and the lake was rough. In this first photograph of three, the *Meteor* heeled sharply to port. (Courtesy of Special Collections, University of Nevada, Reno.)

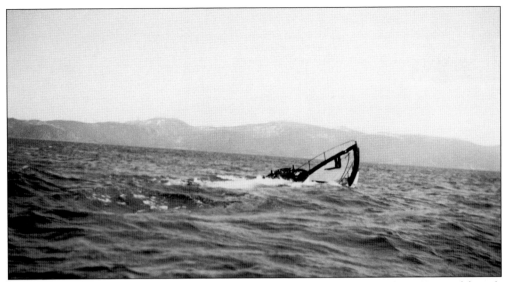

This is the second of three views of the sinking of the Meteor on April 21, 1939. Although eyewitnesses thought that the Meteor might roll completely over, the steamship centered its bow as it raised up towards the sky. (Courtesy of Special Collections, University of Nevada, Reno.)

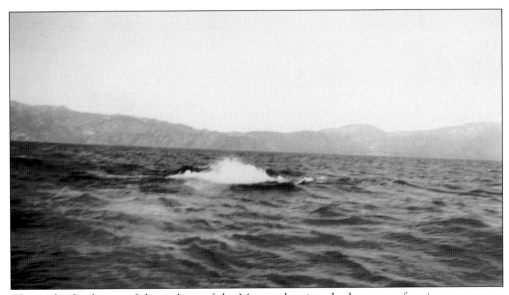

This is the final view of the sinking of the Meteor, showing the last gasp of an important part of Lake Tahoe's history. The Meteor was the first steamer to be deliberately sunk in the lake. (Courtesy of Special Collections, University of Nevada, Reno.)

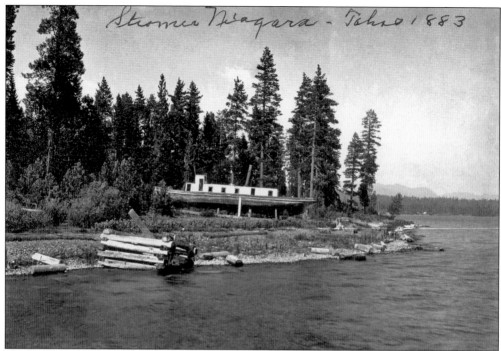

Here the *Niagara* rests on dry land in 1883. This 83-foot-long vessel was the slowest steamer on Lake Tahoe. Originally launched in 1875, sold in 1876 by disappointed owners, and retrofitted in 1877, it became a passenger vessel working primarily between Tahoe City and Glenbrook. By 1880, the *Niagara* was demoted to a tugboat, pulling chained log booms until the demise of the logging industry. By 1905, the *Niagara* was dismantled for firewood. (Courtesy of the South Lake Tahoe Historical Society.)

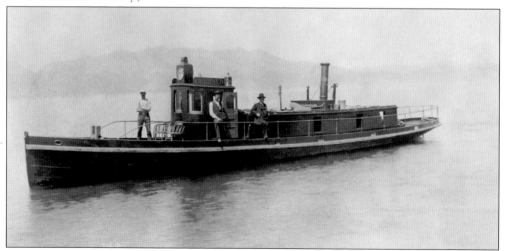

The *Emerald* was stage magnate Ben Holladay's new steamer, launched on July 23, 1869. Navigating the lake was difficult, especially in the earlier days of steamship operations, and after slightly more than two years in operation, the *Emerald* ran aground south of Observation Point. Although recommissioned by 1875, unfortunately the *Emerald*'s boiler was condemned in the fall of 1881, where Tahoe's second steamer was beached on the south shore of Glenbrook Bay. (Courtesy of the North Lake Tahoe Historical Society.)

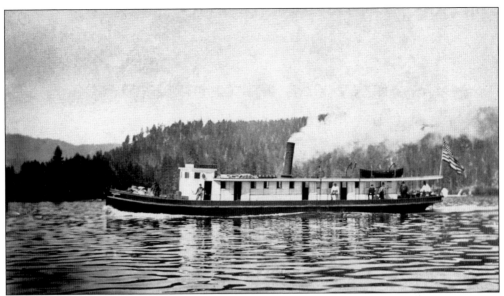

The *Tod Goodwin* was launched near the end of the Comstock industrial period. A permanent canopy surrounded the deck, and the *Tod Goodwin* boasted the highest flagstaff on Tahoe—16 feet above the water. During the summer tourist season, R. J. Waters, veteran Tahoe photographer, was the ship's purser. The *Tod Goodwin* served only 12 years, and was finally beached on the shoreline near Tallac, where her hull broke during the winter of 1898. (Courtesy of the South Lake Tahoe Historical Society.)

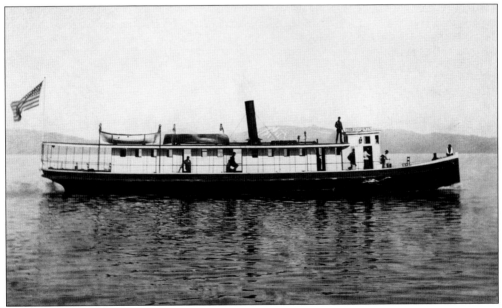

The *Tod Goodwin* accommodated 150 passengers and cruised at 13.5 knots. Although difficult to notice in this photograph, Joseph Todman was a giant of a man, weighing 350 pounds. He was usually on board the steamer, where he conducted the vast majority of his business. The name *Tod Goodwin* was a combination of Commodore Todman's name and his sister's married name, Goodwin. (Courtesy of Special Collections, University of Nevada, Reno.)

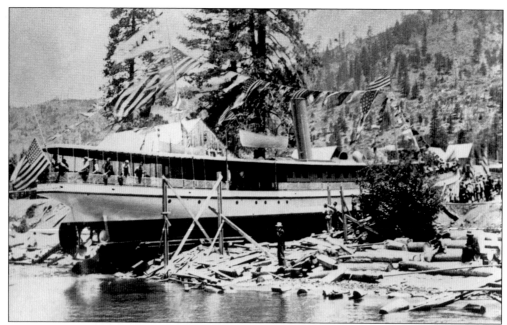

The steamship *Tahoe*, often called the "Queen of the Lake," was launched on June 24, 1896, at Glenbrook. *Tahoe* boasted an electric searchlight, hot and cold running water, and steam heat. During the summer season, it took approximately eight hours to circumnavigate the 73 miles around Lake Tahoe. Although the *Tahoe* stopped service in 1934, the steamer wasn't sunk until August 1940. (Courtesy of the North Lake Tahoe Historical Society.)

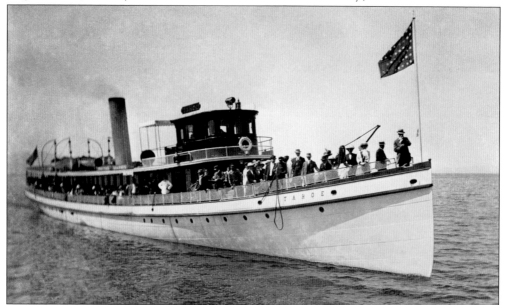

Tahoe was originally owned by the Bliss family, owners of the Lake Tahoe Railway and Transportation Company. The captain, Ernest J. Pomin, served the Bliss family for nearly 45 years, unmatched in Tahoe's marine history. Unfortunately, Captain Pomin died on the morning of December 8, 1919. As he boarded the *Nevada* at Tahoe City, he apparently slipped and fell, striking his head on the side of the boat. He was 71 years old. (Courtesy of the South Lake Tahoe Historical Society.)

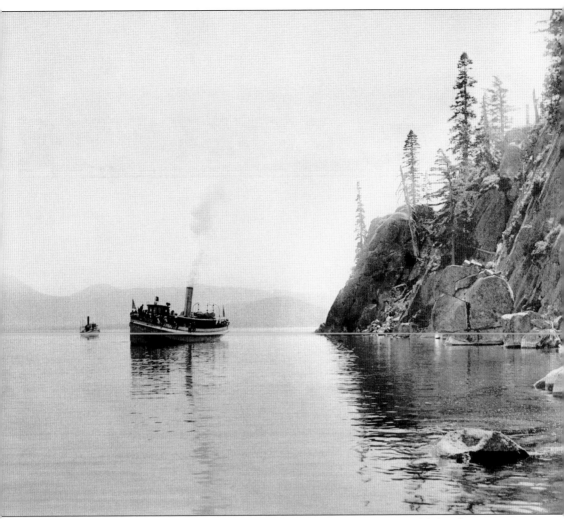

This view pictures the steamer *Tahoe*, with *Nevada* in the distant background, left. The steamer *Nevada* was originally named *Tallac*, built partially in Buffalo, New York. Launched in 1890, *Tallac* was 60 feet long, had a steel hull, a wooden cabin, and was fitted with white scalloped decorations that hung from the deck canopy. *Tallac* was built for luxury and carried 40 passengers. But after a fire gutted the vessel, it was rebuilt, longer by 25 feet, but without the fancy decorations. A few years later, it was sold to Duane Bliss and H. H. Yerington and renamed *Nevada*. (Courtesy of the Nevada Historical Society.)

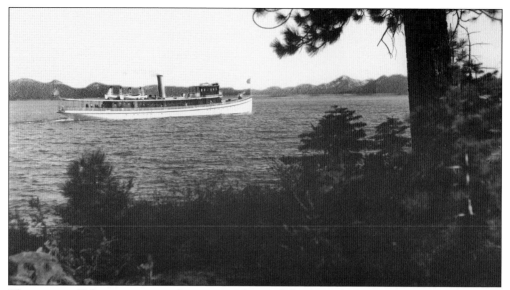

The steamer *Tahoe* was captured as it moved gracefully through the lake's waters. When the *Tahoe* let out a deep-throated whistle, it could be heard around the lake. This sound soon became part of the intrinsic sensory experience of Lake Tahoe. (Courtesy of the North Lake Tahoe Historical Society.)

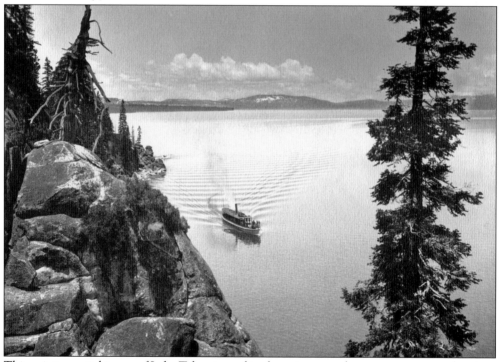

This quintessential image of Lake Tahoe in earlier days pictures calm waters, a spectacular view, tall trees, rocky shorelines, and the steamer *Nevada* pausing at Rubicon Point. In October 1940, the dry-docked *Nevada* became a nuisance, and with the Bliss family's permission, was towed to the center of the lake, drenched with gasoline, ignited, and sunk. This photograph was made on June 14, 1912. (Courtesy of the North Lake Tahoe Historical Society.)

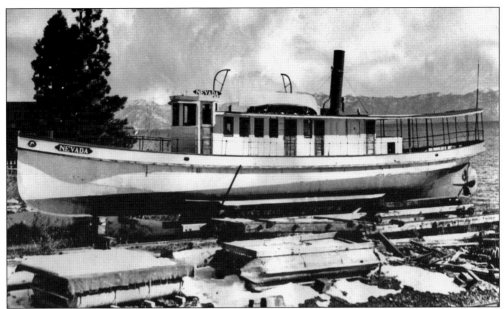

Because the *Nevada* was only outfitted for 40 passengers, the owners advertised its use for the luxury class. For more than 35 years the *Nevada* also carried the mail under government contract. As was the case with all steamers, a time came when it was no longer economically feasible to continue running. In 1938, in keeping with the wishes of the Bliss family, the *Nevada* was dry-docked at Tahoe City. The *Nevada* served nearly 50 years. (Courtesy of the North Lake Tahoe Historical Society.)

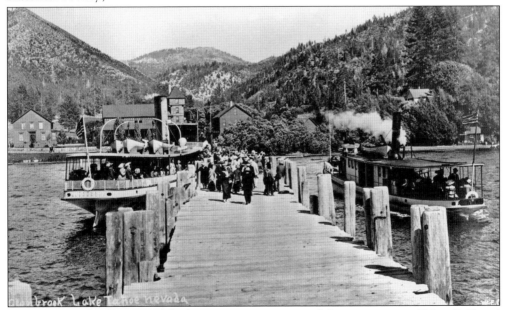

This photograph offers one of the best comparative views of the two steamers, *Tahoe* (left) and *Nevada*. They represent the era of luxury boating on the lake, and they play a significant role in the many tales of storms, survival, business, industry, ownership, and adventure that have become part of the history of Lake Tahoe. This view is made along the Glenbrook pier in 1914. (Courtesy of the North Lake Tahoe Historical Society.)

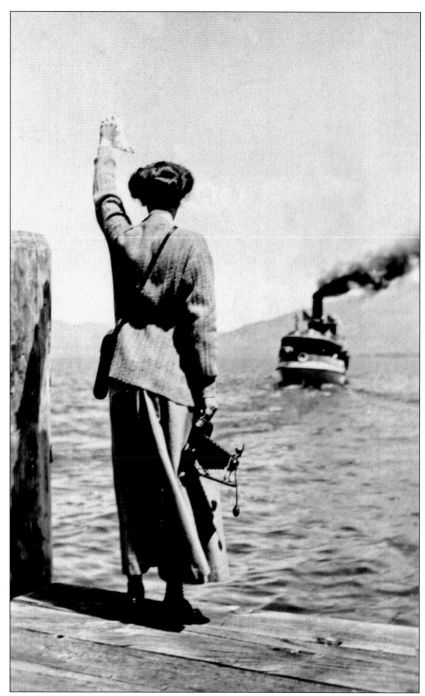

Perhaps symbolizing the end of the steamer era, this photograph aptly shows Mrs. Meyn holding a camera and waving to the *Tahoe* as the steamer departs on yet another journey. Although the history of photography has been principally dominated by males, it is important to recognize the role that many unrecognized female photographers have had in the medium's evolution. The last excursion steamer ceased operations in 1934. (Courtesy of the South Lake Tahoe Historical Society.)

Five

COMMUNITIES AND SITES

SAND HARBOR - LAKE TAHOE

Originally Sand Harbor was a critical juncture in the logging operations of the Sierra Nevada Wood and Lumber Company. Logs rafted nearly 20 miles by the steamer *Niagara* were cable-dragged by teams of oxen up inclined ramps onto logging cars. Today Sand Harbor is part of the Lake Tahoe Nevada State Park, and is the most popular park in Lake Tahoe, as visitors come to enjoy long sandy beaches, rocky coves, and panoramic lake views, accented by the annual Lake Tahoe Shakespeare Festival. This postcard includes a rare view of a seaplane. (Courtesy of the North Lake Tahoe Historical Society.)

In the spring of 1860, Capt. Augustus W. Pray and his associates, N. E. Murdock, G. W. Warren, and Rufus Walton laid claim to the lush Glenbrook meadowland that is now a private enclave for the wealthy. Pray and his associates harvested wild grass that grew abundantly in the meadow, also planting vegetables and wheat. These modest beginnings initiated Glenbrook as one of the earliest Euro-American settlements at the lake. (Perriott Collection, courtesy of the South Lake Tahoe Historical Society.)

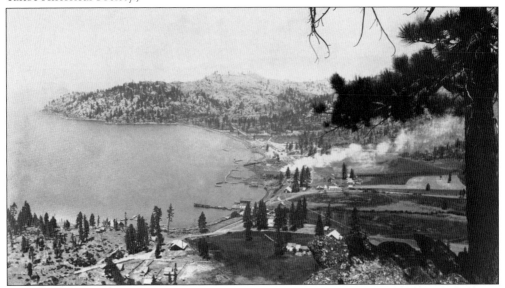

The original caption for this photograph presented this as a view of Glenbrook, but from Shakespeare Cliff. Referencing the vantage point is important because what is now called Shakespeare Rock was a prominent landmark for excursionists traveling on steamers around the lake. According to early accounts of those visiting the lake, experiencing Shakespeare Cliff was obligatory. Sawdust fill along the lakefront dates this view to the industrial period. (Photograph by R. J. Waters; courtesy of Special Collections, University of Nevada, Reno.)

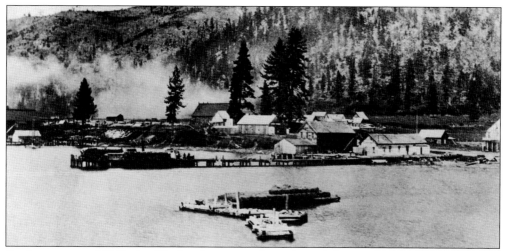

By the summer of 1861, the Glenbrook area was being logged. Pray and his associates built the first sawmill on the shoreline of Lake Tahoe, producing 10,000 board feet a day in addition to shingles. The wharf is stacked with pine slabs. (Perriott Collection, courtesy of the South Lake Tahoe Historical Society.)

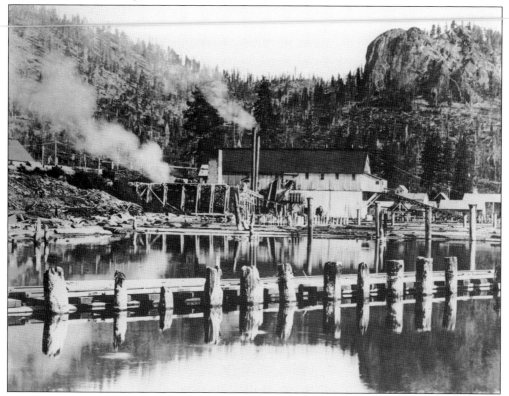

This photograph was made in Glenbrook in 1875. The subject of the image is clearly Pray's Mill, proudly focusing on the industry in early Tahoe. Samuel Clemens (later Mark Twain) came to Tahoe around this time, staking out a timber claim in the vicinity of Glenbrook. Coincidentally, Shakespeare Peak is readily visible in the background. (Courtesy of the Nevada Historical Society.)

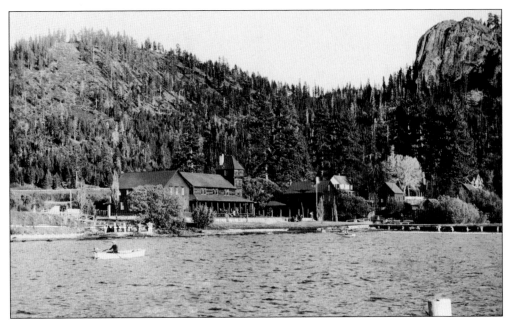

In the summer of 1862, Rev. J. A. Benton's wife had been sketching mountain scenery when she remarked on the resemblance of a deep stain on the side of the bluff, seen here at the right, to a portrait of Shakespeare—hence the name, Shakespeare Rock. This photograph was made years after the decline of the logging industry at Glenbrook. (Courtesy of the Nevada Historical Society.)

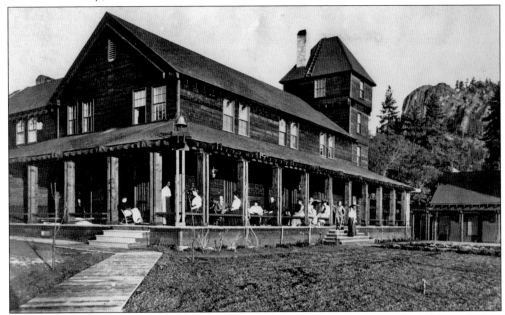

The Glenbrook Inn opened for business in May 1907. It advertised an informal yet relaxing atmosphere, including a veranda overlooking the lake, a dining room, lounging rooms, and a rustic hall for dancing and other entertainment. Many cozy cottages were built nearby, surrounded on all sides by beautiful flowers, contributing to the ambience of the estate. Glenbrook Inn closed in 1975. (Courtesy of the South Lake Tahoe Historical Society.)

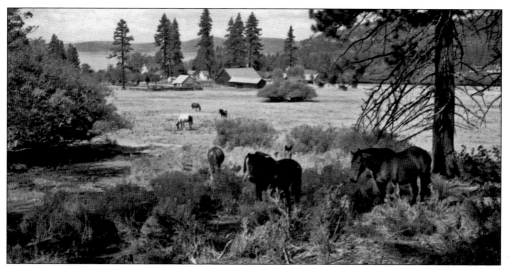

Although originally a postcard meant for the tourist trade, this view of Glenbrook Meadow reflects a pastoral ideal. There have been many views of the meadow made, but they all share a similar pictorial strategy: to frame the open space of the meadow with pine trees or shadows, sloping hills at the distance, and a slice of the lake rounding out the composition. Adding an apparently open range for horses accentuates that ideal. (Courtesy of the Nevada Historical Society.)

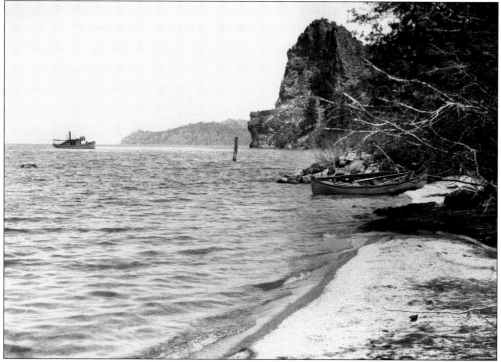

The steamer *Nevada* is approaching Cave Rock principally for the viewing pleasure of excursionists. Note the contrast between the *Nevada* and the small boat beached at right. Picturing this type of comparison and/or contrast is a visual strategy commonly practiced by 19th- and early 20th-century photographers. Using Cave Rock as the compositional center is also important, creating a triangle of visual appeal. (Courtesy of the North Lake Tahoe Historical Society.)

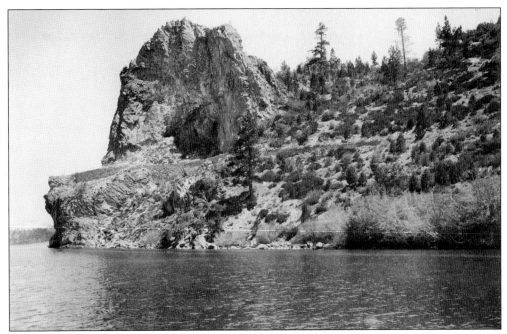

This view from the water is the most common view of Cave Rock, at least from the perspective of the earliest visitors to Lake Tahoe. In the 19th century, there were few roads and not one that circumnavigated the lake, so visitors experienced the view mostly from steamers. This image shows one of the earliest roadway sections, the rock reinforced platform around the left side of Cave Rock. (Courtesy of the North Lake Tahoe Historical Society.)

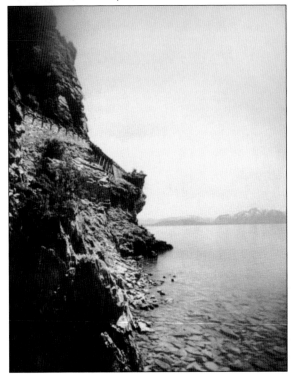

This view of the side of the steep cliff and roadway around Cave Rock demonstrates the precarious construction of the underlying foundation. Workers constructed a cantilevered platform supported by logs embedded in the rock below. The surface was made of wood planking and built like a bridge or trestle, used by horses, mule teams, wagons, and early automobiles for more than 70 years. (Courtesy of the North Lake Tahoe Historical Society.)

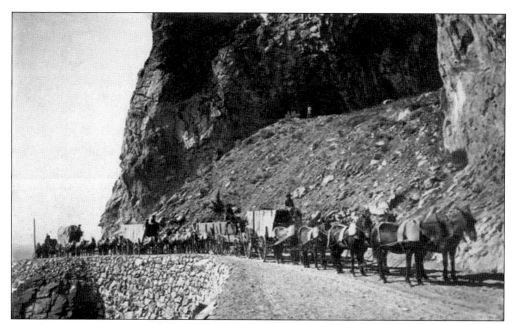

A mule train coming around the southern face of Cave Rock stops to pose, collectively, for the photograph. Note the individual at the top of the cave area looking out towards the lake. Originally a Washoe trail ran above the rock but it was not practical for the kinds of traffic envisioned during Tahoe's industrial period. (Courtesy of Special Collections, University of Nevada, Reno.)

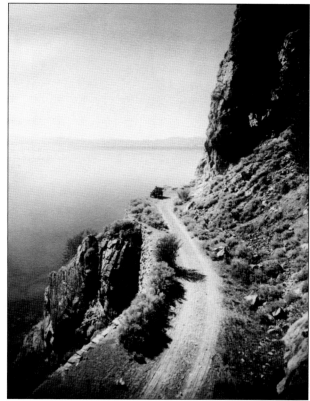

The Lake Bigler Toll Road to Carson City, shown here in 1908, circled Cave Rock and was used for more than 50 years before the present 200-foot-long tunnel was blasted, forever altering the appearance of Cave Rock. The 100-foot trestle bridge and the hand-chiseled stone buttresses—one mile of road—cost $40,000, quite a price at that time. (Courtesy of the North Lake Tahoe Historical Society.)

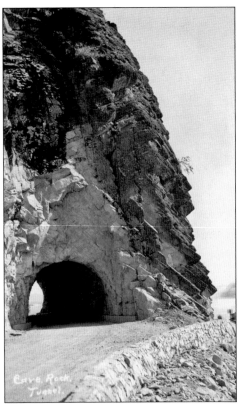

This 200-foot-long tunnel was blasted through granite, destroying much of the original cave. The modern roadway was constructed in two stages. The first tunnel was built in 1931, and its expansion in 1957 completed what is now westbound Highway 50. (Courtesy of Special Collections, University of Nevada, Reno.)

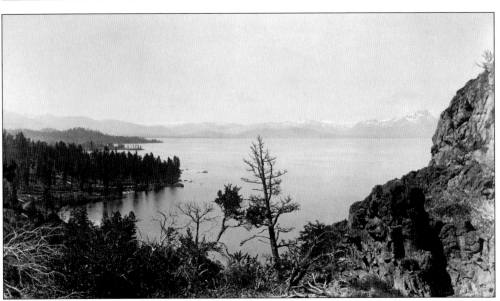

This c. 1886 view looks south from Cave Rock at what is now Lake Tahoe Nevada State Park, established in the late 1960s. This small, day-use area includes a boat launch ramp and dock, comfort station, picnic sites, and a small sandy beach. The entrance is on Highway 50, three miles south of Glenbrook, just south of the Cave Rock tunnels. (Photograph by R. J. Waters; courtesy of Special Collections, University of Nevada, Reno.)

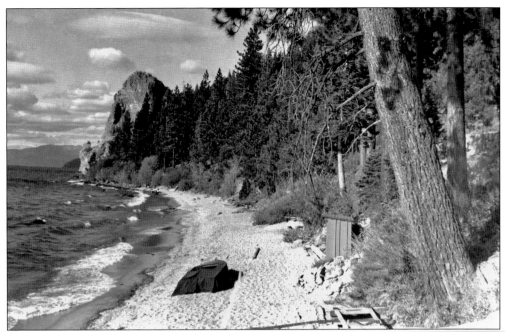

This view looking north at Cave Rock was probably taken from what is now Lake Tahoe Nevada State Park. Dead Man's Point is just visible in the distance. Colorful stories about Cave Rock, embellished in the *Placerville Herald*, were retold numerous times. This photograph was obviously made after the toll road had been made around Cave Rock. If you look very closely, you can see the stone wall on the western side of the rock. (Courtesy of the Nevada Historical Society.)

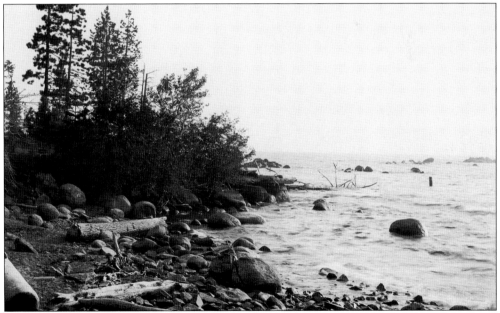

This unassuming view near Cave Rock demonstrates another aspect of Lake Tahoe's scenic appeal. Despite the minimalism of its visual content, the photograph reflects the quiet beauty of an ordinary site, evidence that on every Tahoe shore resides the wonder of water meeting forest. (Courtesy of the South Lake Tahoe Historical Society.)

73

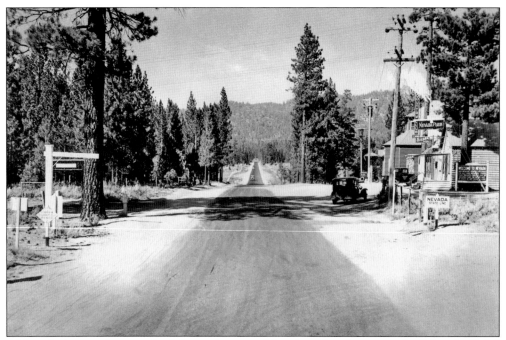

Although this is a photograph of the roadway into Nevada at Stateline, note the "Nevada Club," at middle right, the first gambling house to set up business at the south end of the lake. It was a small establishment, a rough-hewn log cabin with a porch. On March 19, 1931, the day gaming was legalized, gamblers descended upon Nevada, ultimately making it the state's number one industry. (Courtesy of the Nevada Historical Society.)

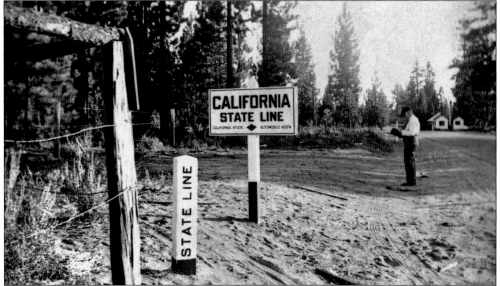

This view looks south from Nevada into California. Named Stateline, this boundary is more than just a dividing line. Nevada was a poor state with few prospects for business, agriculture, or industry, and the potential income from gaming taxes provoked the state government to legalize and tax the industry. In California, gambling was illegal. (Courtesy of the South Lake Tahoe Historical Society.)

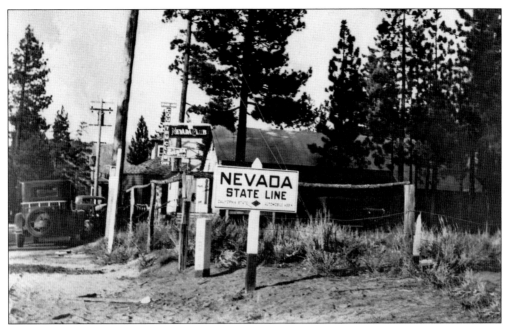

Lake Tahoe is divided between California and Nevada, between gaming and non-gaming economies, between indoor gambling and scenic-based nature economies. This difference is not yet apparent in this photograph, but makes this image much more important, as it documents the borderline before the onset of the huge gaming/entertainment complexes that exist there today. (Dorothy Young Collection, courtesy of the South Lake Tahoe Historical Society.)

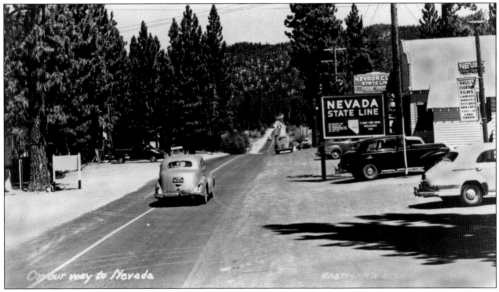

"On our way to Nevada" was originally a postcard. Early slot machines, poker, and wheels of fortune were popular, defining one aspect of the mythic Western character. By 1940, California successfully eliminated gaming from its side of the lake, assuming the higher moral ground by declaring legislatively that gambling was immoral. Gaming now had a forbidden allure, and tourists excitedly made their way to Nevada, especially after it was legalized. (Courtesy of the South Lake Tahoe Historical Society.)

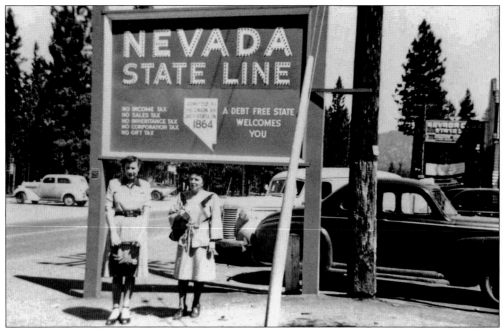

This photograph demonstrates the popularity of visiting a sinful state. Note the text on the Nevada state line sign. "A Debt Free State Welcomes You" proudly proclaims that in Nevada there is no income tax, no sales tax, no inheritance tax, no corporation tax, and no gift tax. Obviously those visiting the state thought it sufficiently important to record their passage into Nevada, as this posed portrait indicates. (Courtesy of the South Lake Tahoe Historical Society.)

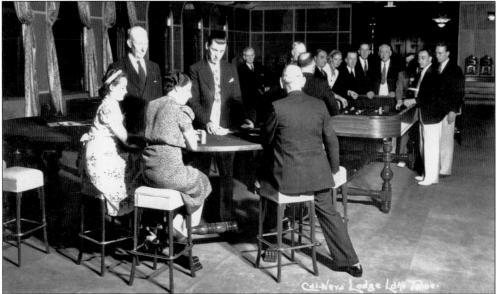

This early record of gambling was posed, but shows both men and women engaged in games of chance. The Cal-Neva Lodge is located at the north end of the lake, at Crystal Bay. Although the state line cuts Tahoe into two political entities, Stateline is a specific place name at the southeastern edge of Lake Tahoe. The boundary runs through the middle of the Cal-Neva Lodge, hence its name. (Courtesy of Special Collections, University of Nevada, Reno.)

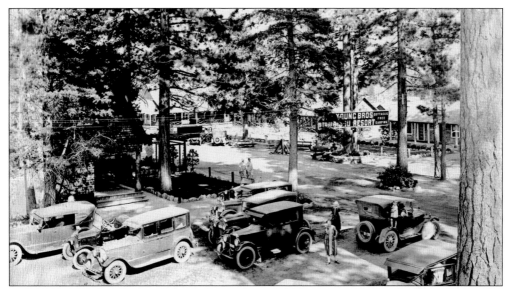

Charlie Parrish owned a hotel that by 1891 was named Bijou House. The name means jewel in French, but the origin of the name in Lake Tahoe's history is vague. The Young Brothers' resort at Bijou was a group of cabins among tall trees adjacent to what is now Highway 50, and it had all the amenities expected by lake visitors, including a premier dance pavilion called the Bal Bijou. This is now the Young Brother's Bijou Resort, east of Al Tahoe. (Courtesy of the South Lake Tahoe Historical Society.)

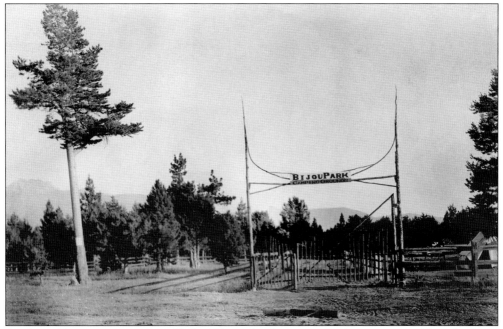

As the public's interpretation of Lake Tahoe's landscape evolved, recreation, although always woven into the industrial past of the Tahoe Basin, became increasingly important. This is a 1920 view of Bijou Park, a campground for those wishing an inexpensive nature experience. Today Bijou has been completely absorbed into the greater metropolitan area of South Lake Tahoe. (Courtesy of the South Lake Tahoe Historical Society.)

Bijou, once a flourishing lumber camp, was originally called Taylor's. By 1898, Bijou lumber had closed and the Carson and Tahoe Lumber and Flume Company removed the Bijou rails, flat cars, and equipment, leaving only a sagging roundhouse, blacksmith shop, and mile upon mile of slash, bark, and land covered with rotting log chutes, cordwood, camps, and other industrial detritus. This is the Bijou Post Office, moved from Rowlands in 1888. (Courtesy of the South Lake Tahoe Historical Society.)

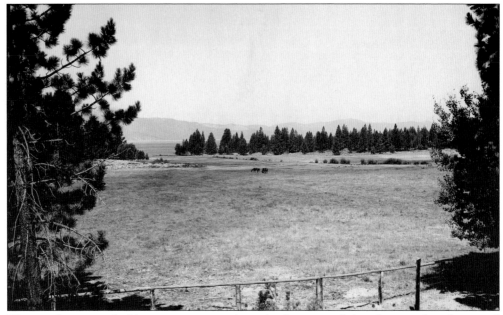

The meadow is a valuable resource in an alpine landscape, and therefore worthy of pictorial representation. This view celebrates the rich, fertile landscape. Sections of this meadow survive, which is surprising given the abundant commercial growth in South Lake Tahoe. The city of South Lake Tahoe is the only incorporated city in the basin, and as of 2005 boasted a population of 34,000 people. (Courtesy of the South Lake Tahoe Historical Society.)

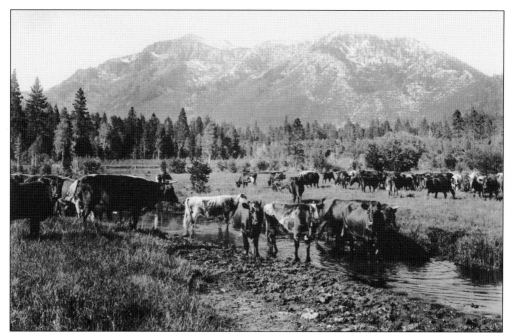

Early Euro-American settlers in the Tahoe Basin recognized the agricultural potential of meadow grasses. Here cattle stand in Taylor Creek and graze throughout Dairy Meadow. Once the logging camps closed, and the demand for dairy cattle subsided, beef cattle were substituted. Grazing is no longer permitted in this area, managed by the U.S. Forest Service. Prominent in this view, in the distance, is Mount Tallac. (Courtesy of the North Lake Tahoe Historical Society.)

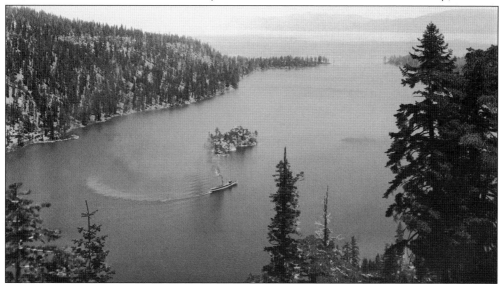

This quintessential Lake Tahoe image shows the steamer *Tahoe* circling Fannette Island in Emerald Bay. During the summer of 1863, Ben Holladay Jr., son of an overland stage magnate, assumed control of most of the land surrounding Eagle Bay, later named Emerald Bay. Soon he built a two-story, five-room, summer residence near the lakeshore, northwest of Eagle Falls. Called the cottage, it was the first private vacation home built at Lake Tahoe. (Courtesy of the North Lake Tahoe Historical Society.)

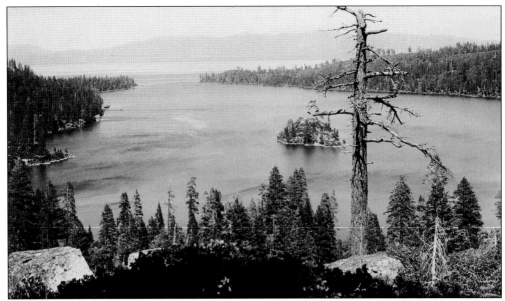

Capt. Richard Barter, colorful character and self-proclaimed hermit of Emerald Bay, declared this island his cemetery, excavating and building a solid rock tomb at the summit. Unfortunately he drowned in an unexpected gale in 1873 and his body was never recovered. By some accounts, what is now labeled on some contemporary maps as Fannette Island was called Dead Man's or Hermit's Island in honor of Captain Barter. (Courtesy of the South Lake Tahoe Historical Society.)

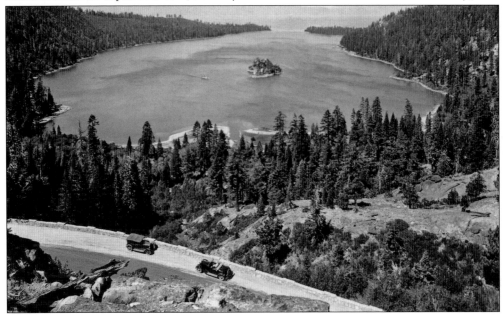

As road construction techniques improved, the overall safety of the roadway around Emerald Bay became less and less of an issue for the motorist. Yet in 1955, heavy rains caused a 1,600 foot landslide, washing out the roadway through 1956. Although replaced and resurfaced numerous times since then, the roadway is commonly closed during the severe winter months. Although difficult to see, there is a steamer approaching Fannette Island. (Courtesy of the South Lake Tahoe Historical Society.)

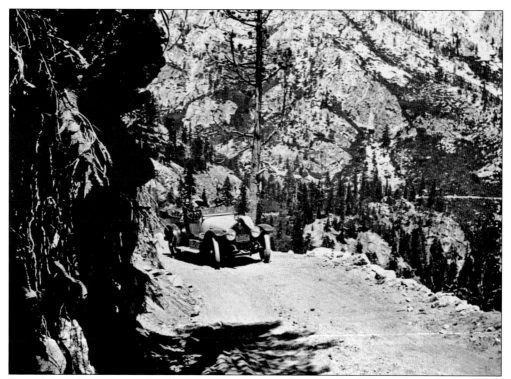

Rim of the Lake road, completed in 1913, became one of California's first scenic highways. During construction, steamers slowed, allowing visitors to marvel at the steep, rocky terrain. With each blast, boulders and gravel burst out into the void, a startling and dramatic theater of sight and sound. Regardless of the weather, drivers needed skill and extreme caution to avoid an accident, with little hope of finding immediate help. (Courtesy of the South Lake Tahoe Historical Society.)

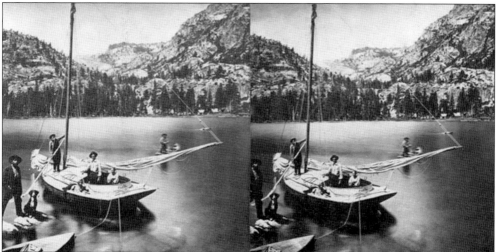

This is a stereograph by Thomas Houseworth and Company, San Francisco, titled "Eagle Canyon from Eckley's Island, Emerald Bay, Western Shore of Lake Tahoe." Shown are Dr. Kirby and his wife in their racing yacht, the *Fleeter,* which was used for racing and guest excursions. Note that the photographer included a bow of a boat in the foreground to accentuate the 3-D illusion. (Courtesy of Special Collections, University of Nevada, Reno.)

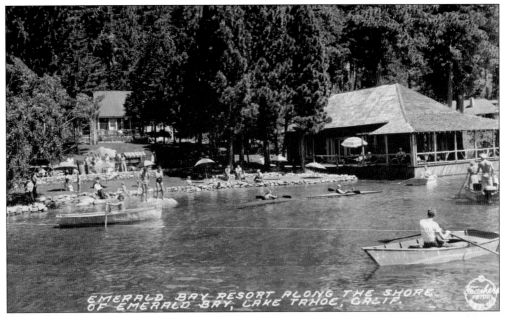

This postcard advertises the Emerald Bay Resort. Sheltered and scenic, by 1881 Emerald Bay had become a favorite excursion destination for tourists and residents. Numerous steamers made this area a primary landing spot. By the spring of 1884, this site boasted a small hotel, a few small cottages, tents, and of course, a steamer landing. (Courtesy of the North Lake Tahoe Historical Society.)

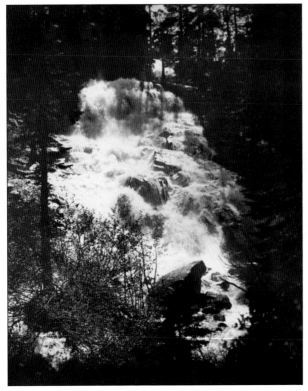

Sheer granite walls rise on the western and northern faces of Emerald Bay, leading more than 2,600 feet up to the aptly named Inspiration Point. The view is spectacular, but turning away from the lake reveals another view, that of Eagle Falls. Its waters are fed from Eagle Lake farther up in the Desolation Wilderness. This is a popular rest area along the drive circumnavigating Lake Tahoe. (Courtesy of the North Lake Tahoe Historical Society.)

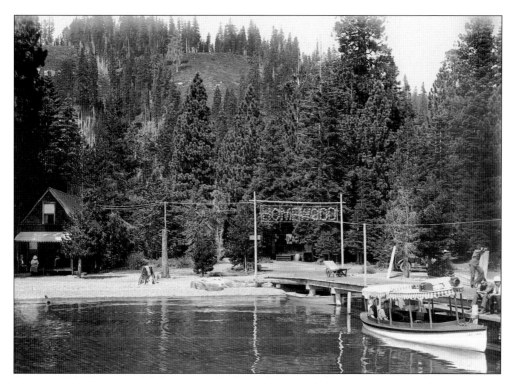

Prior to 1880, Homewood did not exist. Early settlers passed the current site, preferring to camp or rest near the creek outlets along the western side of the lake. Homewood was a 20th century settlement, as the first post office was established on July 31, 1909. The following summer, a family resort was under construction, precursor to the one pictured here. This photograph was made in the 1920s. (Courtesy of the North Lake Tahoe Historical Society.)

The site of present-day Tahoe City has always been critical to the history of Lake Tahoe. In part, this is because it lies on the lake's western shore, directly north of the Truckee River's headwaters, where many visitors first reach the lake. Known in early post office records simply as Tahoe, Tahoe City was officially established in the fall of 1863. This photograph was made c. 1888. (Photograph by R. J. Waters; courtesy of the Nevada Historical Society.)

In 1865, Tahoe City had only 15 year-round residents. But by 1870, Tahoe City had become an embarkation point for tourists, including curiosity seekers and speculators traveling the recently improved canyon route from the new Central Pacific Railroad station in Truckee. At the time this photograph was made, Tahoe City had several marinas and a picnic ground, known as the Tahoe Commons, which was confirmed by an act of Congress in 1867. (Courtesy of the Nevada Historical Society.)

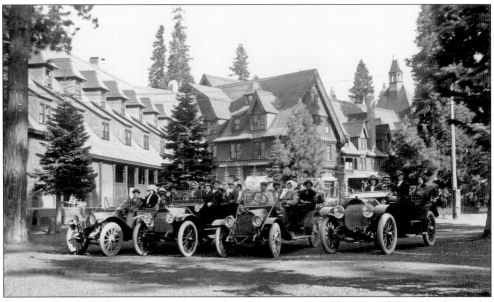

In its heyday, the Tahoe Tavern, with its wide porches, manicured lawns, and flower beds was the showcase of Lake Tahoe. The Tavern Annex, south of the main hotel, was added in 1906 and the Casino, north and below the main building, in 1907. These guests proudly pose with their automobiles, symbols of wealth and progress. For years, Tahoe Tavern was known for catering to the carriage trade, even offering specialized parking. (Courtesy of Special Collections, University of Nevada, Reno.)

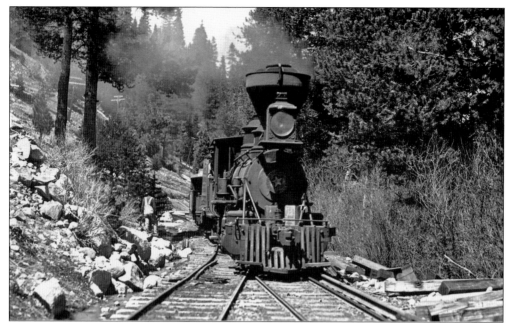

The Lake Tahoe Railway and Transportation Company carried passengers round trip from Truckee to Tahoe City, significantly developing Tahoe's tourism. Now, thousands of vacationers could easily reach the lake in comfort. This was the only public transportation to the lake until automobile highways were built. The last train from Truckee to Tahoe City ran in 1942, whereupon the track was removed and sold for the war effort. (Courtesy of the North Lake Tahoe Historical Society.)

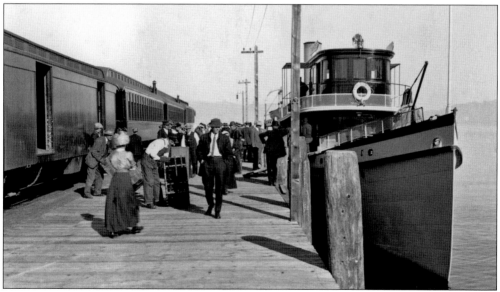

This is a classic view of Lake Tahoe, showing the Tahoe Tavern pier with the steamer *Tahoe* on the right and a passenger train disembarking on the left. Through 1924, the Tahoe Tavern provided a terminal for the lake steamers and trains of the Lake Tahoe Railway and Transportation Company. Tickets for a one-day excursion were presold, and usually sold out long before the voyage got underway. (Courtesy of the North Lake Tahoe Historical Society.)

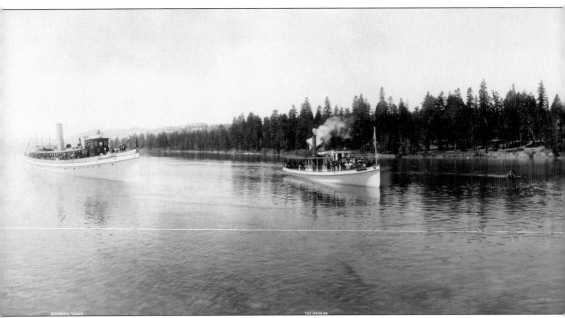

This unusual and detailed panorama of Lake Tahoe manages to capture the quintessential early Tahoe—a natural luxury resort destination. On the far left is the steamer *Tahoe,* in the middle, the *Nevada,* and closest to the pier, the Mi Dueña. The Mi Dueña was considered one of Tahoe's show boats, a 50-foot cruiser that was later shipped to the Oakland Estuary. The Tahoe Tavern is behind the *Mi Dueña.* This photograph was taken from the end of the Tavern Wharf. At Truckee, excursionists left the familiar Southern Pacific train, with its powerful locomotive, to walk to the comparatively much smaller Tahoe train, with its two or three coaches, open air observation car, baggage car, and a smaller engine defined by its balloon smokestack. The trains

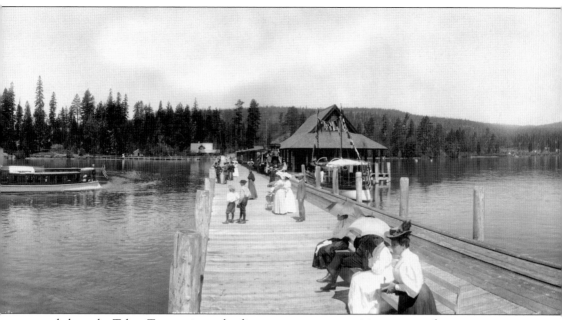

stopped along the Tahoe Tavern pier, unloading passengers onto waiting steamers for excursions to Glenbrook, Tallac (a hotel on the south shore), or one of the other north shore resorts. However, tourists often stayed overnight at the Tahoe Tavern, which was designed to offer a vacation more luxurious than any other resort hotel on the lake, emphasizing comfort and excellent cuisine in a refined and relaxed atmosphere. Outdoor recreation was a natural draw, and included fishing, horseback riding, swimming, tennis, boating, and picnicking. (Courtesy of Special Collections, University of Nevada, Reno.)

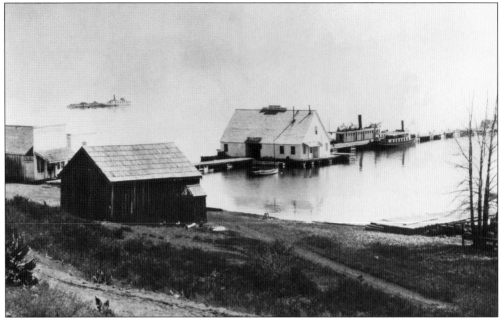

In this view of the Custom House building at the Tahoe City marina, the steamer *Todd Goodwin* is alongside the pier, on the left side as you walk toward the lake, and on the right is the *Emerald II*. The *Tallac*, later named the *Nevada*, is in the upper left background. Launched in 1869, the *Emerald II*, taking the name of Ben Holladay's wooden-hulled steamer, was an iron vessel, considered a marine workhorse, delivering logs to Glenbrook's mills. (Courtesy of the North Lake Tahoe Historical Society.)

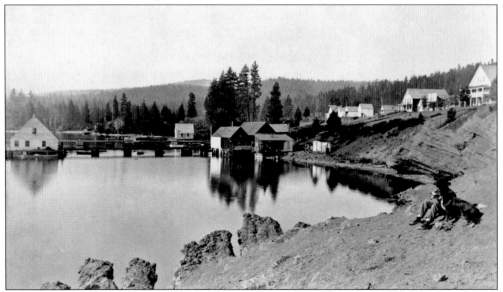

This is another view of the Custom House, whose name derived from the custom for visitors to consume alcohol immediately after entering. In the 1870s Tahoe City grew to 50 houses, two hotels, three saloons, a general store, and a new wharf. Note also the boy and his dog, far right, observing the photographer's view and adding a human touch to the scene. (Courtesy of Special Collections, University of Nevada, Reno.)

To attract people to the National Ski Championship Tournament, held from February 26 to 29, 1932, the Southern Pacific Railway laid broad gauge rails on the abandoned narrow gauge railroad bed from Truckee to Tahoe City. The track is visible, far right. Note the steamer, possibly the *Tahoe,* docked along the pier, far right. To the left of the power line is the main street of Tahoe City. (Courtesy of the North Lake Tahoe Historical Society.)

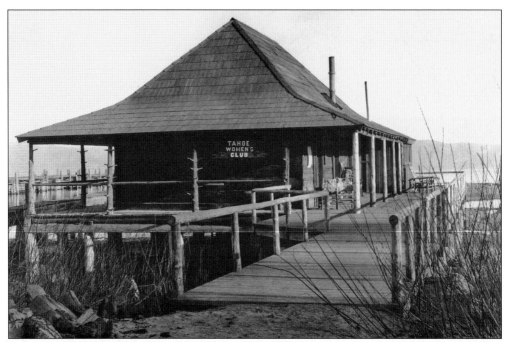

Recreational opportunities were often segregated within the Tahoe Basin. This is a photograph of the Tahoe City Women's Clubhouse that was built over beach water. Unfortunately it burned to the lake level along with the Tahoe Mercantile store and post office in the early morning of October 21, 1937. (C. W. Vernon Collection, courtesy of the North Lake Tahoe Historical Society.)

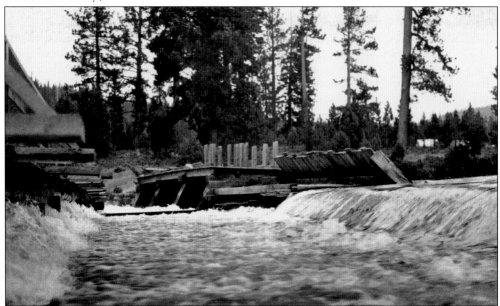

In 1865, Col. A. W. Von Schmidt assumed the presidency of the Lake Tahoe and San Francisco Water Company and acquired the rights to construct a dam 150 yards downstream from the lake's outlet. By the fall of 1870, a crib dam of timber and stone fill was completed. This is a flood over the dam's spillway. (Courtesy of Special Collections, University of Nevada, Reno.)

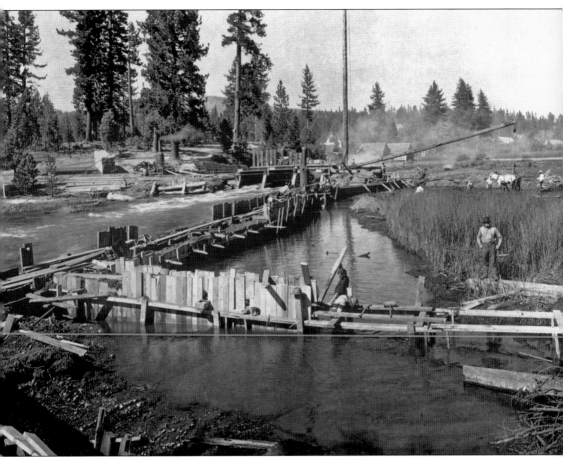

This *c.* 1912 view faces northeast in the direction of the Commons of Tahoe City. Harold Parker, the photographer, was standing in what was then marshland bordering the south side of the Truckee River. Given Lake Tahoe's watershed, the enormous amounts of water entering the lake had overpowered the original crib dam. The inevitable demands for the management of Lake Tahoe's waters for downstream uses, specifically in the metropolitan areas of Reno and Sparks, the Paiutes at Pyramid Lake, and the farmers at Fallon led to the construction of a more modern, concrete dam. Due to contractual complications, this second dam remained unfinished until the fall of 1913, after the view above was taken. As detailed in this author's book, *A Doubtful River* (University of Nevada Press, 2000), many conflicts arose about the Truckee River and the division of Lake Tahoe's water among competing interests. (Photograph by Harold A. Parker; courtesy of Special Collections, University of Nevada, Reno.)

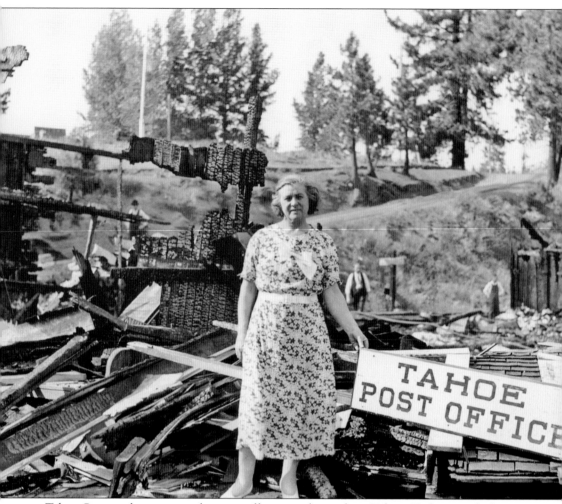

Tahoe City was known in earlier post office records simply as Tahoe. Unfortunately fire was a part of early settlement history and after this fire, all that remained of the Tahoe Post Office was the sign. (Courtesy of the North Lake Tahoe Historical Society.)

Six

RECREATION

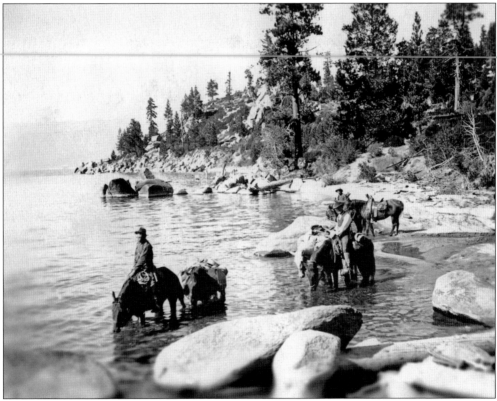

Recreational pursuits coincided with the earliest Euro-American activities in the Tahoe Basin. Although Tahoe's period of settlement was principally dedicated to harvesting and exploiting the area's resources, visitors understood the natural beauty, spectacular clarity of the water, and the potential for appreciating the lake beyond its economic value. The original caption on this photograph indicates that this is a guided horseback trip, and although the specific purpose is not discernible, a cursory review of the image reveals that they are carrying sufficient gear to spend quite a few days in the backcountry. (Courtesy of the Nevada Historical Society.)

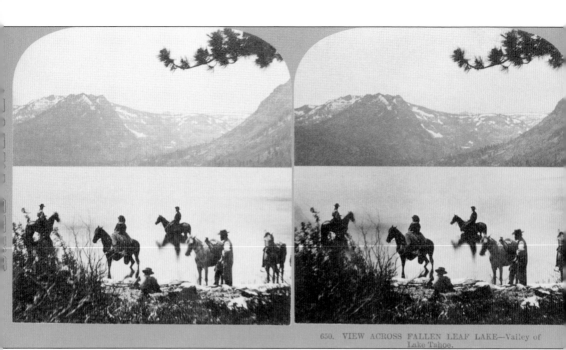

650. VIEW ACROSS FALLEN LEAF LAKE—Valley of Lake Tahoe.

This stereograph was composed to create a sense of 3-D relief, with a figure and some vegetation in the foreground, horses and riders in the middle ground, and the scenic majesty of the mountains in the background. As the film speed was not as high as in today's varieties, everyone, including the horses, had to stand still for more than a few seconds. This scene was carefully constructed and reflected the prevailing desire for entertaining views of Lake Tahoe. The stereograph is titled, "View across Fallen Leaf Lake, Valley of Lake Tahoe." The publisher was Thomas Houseworth and Company, San Francisco. (Courtesy of Special Collections, University of Nevada, Reno.)

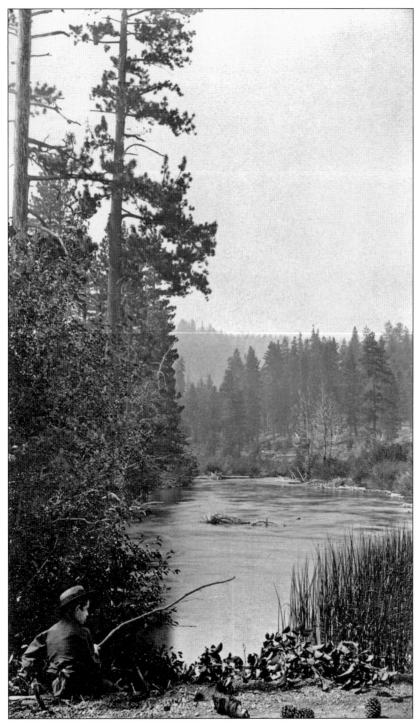

The bucolic ideal expressed in Mark Twain's writings is reflected in this view of a boy fishing in the Truckee River northwest of the outlet. Composed for the view c. 1886, it typifies the sentimental compositions favored by this photographer. (Photograph by R. J. Waters; courtesy of Special Collections, University of Nevada, Reno.)

This is another image in the genre of pastoral portraits sympathetic to the impressionist sensibility of the gentle, Tahoe landscape. Note that the woman is posing off in the distance as a way of establishing the scale of the tall trees. Even so, the trees still exceed the confines of the photographic frame. Note, too, that the woman is riding sidesaddle. (Courtesy of the North Lake Tahoe Historical Society.)

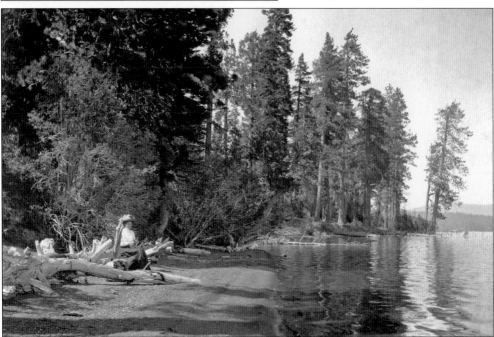

Over the years, thousands of such vernacular views must have been made. Pictured here is Fannie Dodd, posing for an unidentified photographer. The original caption on the photograph indicates that this image documented a picnic. The rustic isolation of the scene is a romantic compliment to the experience. The photograph is dated 1913. (Courtesy of the Nevada Historical Society.)

These two women on the beach at Lake Tahoe are either washing dishes or panning for gold, however unlikely it would be to find ore at the edge of the lake. Regardless, after the hardscrabble days of mining and lumbering, the concept of panning for gold became a popular recreational activity for visitors. These ladies are quite fashionably dressed for the outdoor life. (Courtesy of Special Collections, University of Nevada, Reno.)

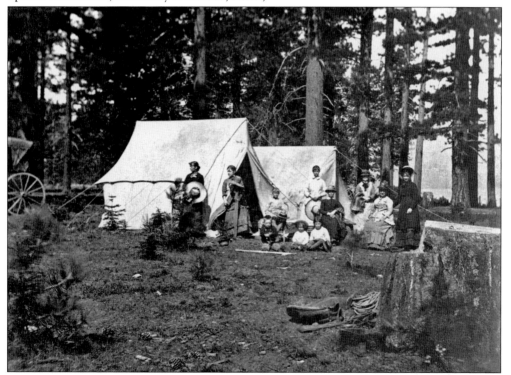

Camping as a recreational activity came early to the Tahoe Basin. Once roadways became passable, people flocked to beautiful Lake Tahoe as an alternative to more expensive resorts. Note the wagon at the far left edge of the photograph, and note that the people posing for the photograph are dressed in their Sunday best. The whereabouts of the men accompanying this group is unknown. (Courtesy of the Nevada Historical Society.)

There is something quite elegant about having a fancy meal, replete with bottled beverages and china cookware, in the wilderness. A makeshift dining table is easily constructed, and the white linen tablecloth adds the necessary flair for just such an experience. This photograph, dated *c.* 1878, provides just one example of the universal appeal of dining on Lake Tahoe's shores. Note that all are dressed appropriately for the occasion. (Courtesy of the South Lake Tahoe Historical Society.)

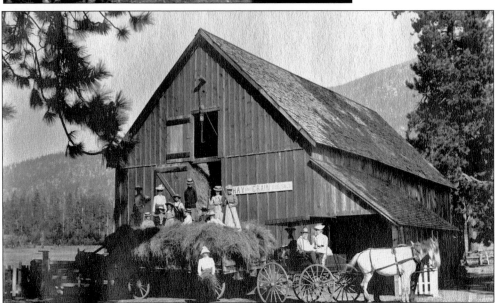

Getting ready for a hayride at Hobart's Landing are Mr. and Mrs. E. B. Smith in the front seat of the buggy; Mattie Hobe, Laura and Ed McFaul, the Heiberts, and Joe Hall on the hay wagon. Taking a hayride is one of the great pastoral traditions of the leisure class. The original caption on this photograph, dated 1901, indicates that this is the historic Lakeside barn and stable. (Photograph by Arthur M. Hill; courtesy of the Nevada Historical Society.)

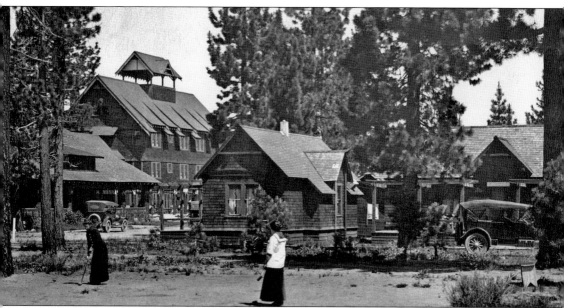

Originally a panorama, this photograph portrays the Al Tahoe Inn and cottages. The Al Tahoe Hotel was a resort development that combined some aspects of the hotel resort with a less expensive family atmosphere. In 1916, the resort boasted electricity and soon thereafter had a telephone connecting the hotel to Gardnerville in Nevada. Al Sprague created the name Al Tahoe by combining his first name with Tahoe. When the hotel was purchased by Frank Globin in 1924, the name was already deeply associated with the site, explaining why the new resort was called Globin's Al Tahoe. Note the two women engaged in croquet, just to the left of center. (Photograph by L. H. Bannister; courtesy of the South Lake Tahoe Historical Society.)

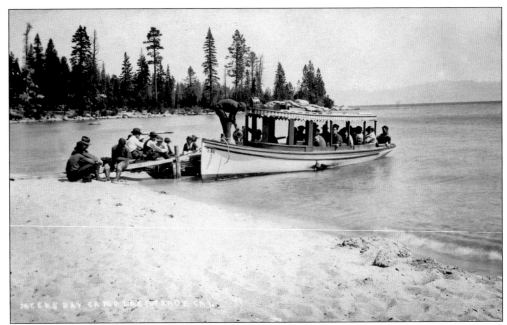

Meeks Bay is at the terminus of Meeks Creek, north of Rubicon Bay. Although completely logged, in 1919 Oswald V. Kehlet developed a public campground near this landing. By 1929, a post office was officially established at the bay, emphasizing the concept of resort camping for extended stays. This is a postcard view of a camp boat, testament to photography's role in commercializing the view. (Courtesy of the North Lake Tahoe Historical Society.)

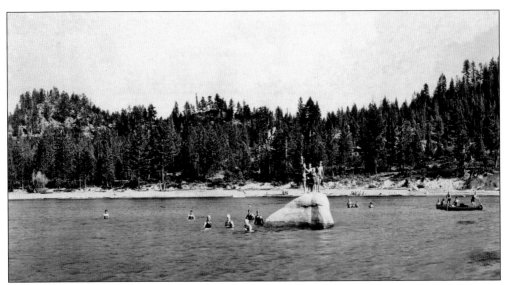

These swimmers c. 1920 braved the lake's cool waters. According to contemporary studies, the water temperature of the surface of Lake Tahoe ranges from a low of 41 degrees fahrenheit to a high of 68 degrees fahrenheit. In the best of circumstances, the water is chilly, even if remarkably clear. In fact, until recently, Lake Tahoe's water was considered 99.9 percent pure. (Courtesy of the Nevada Historical Society.)

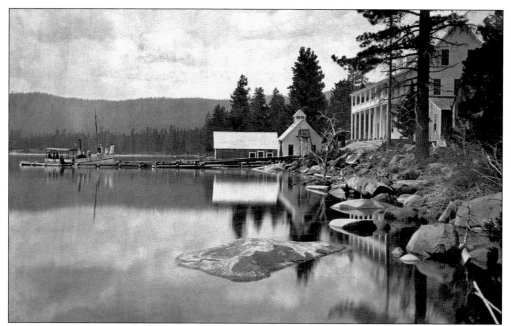

In 1869, William "Billy" Campbell, a stage company owner, acquired 63 acres in what is now Brockway. There, at the water's edge, he and his partners built a bathing house named Campbell's Hot Springs. This 1872 photograph shows the boat sheds and bathhouse (center) and hotel with veranda (right). Lake Tahoe became a destination for those wishing, or needing rest and relaxation, hence one suggested name for the lake, Lake Sanatoria. (Courtesy of the Nevada Historical Society.)

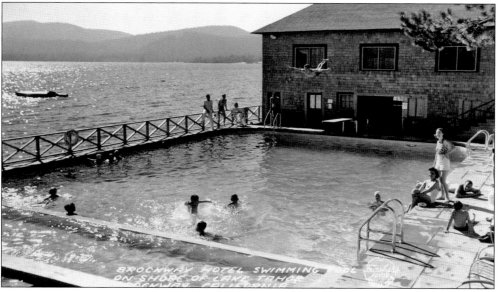

In 1899, Campbell's Hot Springs fell into disrepair. In 1900, Frank Brockway Alverson and his wife Nellie reinvigorated the resort and renamed it Brockway Hot Springs. Unfortunately only nine years later the Alverson's filed for bankruptcy. Shortly thereafter, under different owners including Harry Comstock, the Brockway casino and dining room were built. This swimming pool was added in the 1920s. (Courtesy of the North Lake Tahoe Historical Society.)

This portrait of an unidentified girl reflects a vernacular form of "technostalgia," a term describing our collective tendency to sentimentalize the history of industry and technology. The size of the wheel is a consistent theme throughout these histories, and this girl is here as much as a tool to provide scale as it is to record her likeness. (Courtesy of the South Lake Tahoe Historical Society.)

It was once considered inappropriate for professional photographers to record a blur, however intentional it might be. Either they would use a fast shutter speed, or the subject would try to freeze, often unsuccessfully, in mid-motion. In the freedom of this vernacular undated snapshot, the humorous caption explains, "Ice skating—camera too slow for Sharley." (Courtesy of the South Lake Tahoe Historical Society.)

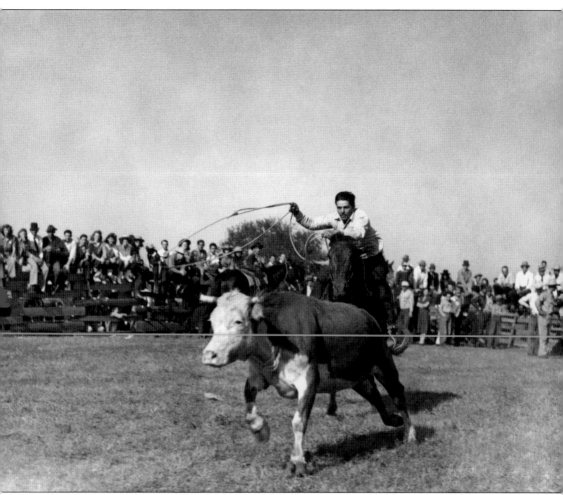

This is a skillful photograph of a roping contest at the Glenbrook rodeo in 1947. William Bliss, owner of the Glenbrook Inn, was an amateur rodeo roper. Beginning in 1939, Bliss and his employees constructed a roping arena close to the Glenbrook hay barn and apple orchard. Their idea was to have a nearby site for their own roping practice, but also to entertain the inn's guests. Will Bliss's cowboy friends from nearby ranches in Carson, Smith, and Mason Valleys began to show up on weekends, and the Glenbrook rodeos were born. Within a few years, three Sunday rodeos were held at Glenbrook each summer, with calf and team roping, steer stopping, a girls' barrel race, and occasionally wild cow milking. (Courtesy of the Nevada Historical Society.)

Our Tahoe Trip.

In the cold gray dawn of
Saturday morning, July 18, the
peaceful slumbers of Manzanita
Hall were rudely awakened
by the shrill sounds of alarms.
Quickly the girls jumped from
their beds and made ready
for the trip to Tahoe. We all
met in the main hall laden
with suitcases and lunch boxes
which had been packed on
the day previous. Then as
the sun's first rays began to

Combining text and photography in scrapbooks was a popular method of preserving the experience of Lake Tahoe visits. This story continues on numerous pages, mostly discussing how difficult it would be, even for art students, to do justice to the "wonderous [sic] enchantment of earth and sky." These young ladies from the University of Nevada, Reno, had enjoyed a steamer voyage to Emerald Bay. (Courtesy of Special Collections, University of Nevada, Reno.)

Camp Chonokis was established in 1927 by Mabel Winter and Ethel Pope as a summer and winter camp for girls, ages 8 through 18. Camp Chonokis was located about a half mile from the edge of Lake Tahoe at Stateline, South Lake Tahoe, California. This photograph, from a summer session, is captioned, "swing on tennis court." (Courtesy of the South Lake Tahoe Historical Society.)

The central idea of the founders of Camp Chonokis, who were both teachers, was that girls could benefit from a loosely structured outdoor experience, in contrast to the more regimented program of their individual schools. The regular camp session lasted six weeks during the summer, although in 1945, an additional four-week session was offered at the request of the government in an effort to remove children from the cities during World War II. The winter camps were much shorter, usually only one or two weeks, and were attended by only a few campers during their Christmas school vacations. The waters of Lake Tahoe are unpredictable—sudden squalls and unstable airflows can create difficult boating circumstances with little warning. The girls attending Camp Chonokis learned how to work together, especially when it came to paddle practice, here conducted on the beach. This photograph is an instance where practice and posing merged, making it difficult to tell where one activity begins and the other ends. (Courtesy of Special Collections, University of Nevada, Reno.)

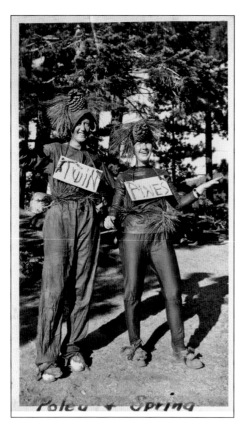

In 1928, after only one summer of camp activity, Mabel Winter bought out Ethel Pope's interest in Camp Chonokis. By the opening of the 1930 season, Gladys G. Gorman, another teacher, had joined the camp team. This is a photograph from a twin theme party, and is titled, "Twin Pines, Poley and Spring, Camp Chonokis." (Courtesy of the South Lake Tahoe Historical Society.)

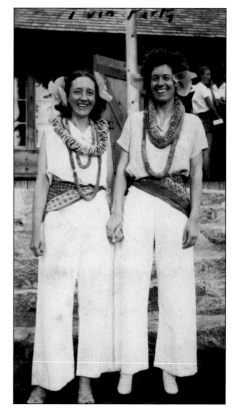

Horseback riding played a major role in camp activities, as did drama, hiking, choral music (including Russian and Latvian songs), dancing, crafts of all kinds, and water sports. Every year, the camp put on a rodeo in one of the meadows and dramatic plays in the open air theater, to which the public and parents were invited. This 1940 photograph is captioned "Twin party, Mary 'n' Howie, Camp Chonokis." (Courtesy of the South Lake Tahoe Historical Society.)

An enduring tradition of nicknames took hold at Camp Chonokis: Mabel Winter was Bliz (for Blizzard), and her office in the lodge was the North Pole; Gladys Gorman was G for her initials; and another counselor, Margaret McKenzie, was Mugs. Mugs was a camper the first season, a counselor for three years, and never lost touch with the camp through all its years. This photograph records a "Deer from Robin Hood, Camp Chonokis." (Courtesy of the South Lake Tahoe Historical Society.)

Summers at Camp Chonokis were remembered with special affection by all those who enrolled. Poems and prose went into yearly "Chonokis Logs." These, plus the photograph albums for each camp season, attest to the enthusiasm of campers who hiked, swam, rode, and played among the sugar pines. Another camp activity encouraged witty costume events. Here "Mary N." is dressed as a wood tick. (Courtesy of the South Lake Tahoe Historical Society.)

Camp Chonokis encompassed 20 acres and consisted of a main lodge, shower house, and tent cabins. In the early 1930s, a log house, shown above, named *Tyschina* (a Russian word meaning peace or calm) was added. Mabel Winter oversaw its construction, thinking that it would be her home after she retired from teaching. During the summer, campers and counselors used it for reading, music, small parties, and meetings. This is a view of the main living room in 1936. The original caption says, "Bench made by John Nolan . . . No wood box yet." In 1948, Mabel Winter married Robert B. Whitney and from that time on lived during the off season with her new family in Amherst, Massachusetts. Apparently the demands of a large family made it too difficult to run a camp 3,000 miles away, because in 1953 Mabel Whitney leased the facilities to J. Wendell Howe and Jimmee Dodson, a former camper and counselor. Camp Chonokis did not reopen after that year, although the Whitney family continued to drive across the country to spend their summers in the log house on the property. Camp Chonokis is now owned by the United States Forest Service. (Courtesy of Special Collections, University of Nevada, Reno.)

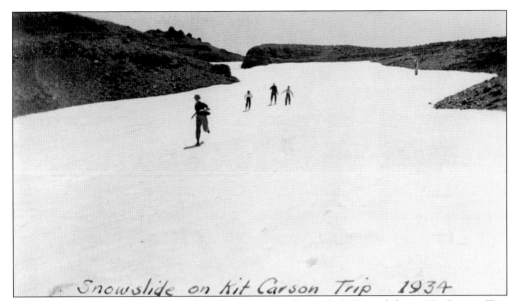

Snowslide on Kit Carson Trip 1934

Made by hikers from Camp Chonokis, this photograph is titled "Snowslide on Kit Carson Trip 1934." The extensive collection of visual and textual material from Camp Chonokis at the Special Collections Department, University of Nevada, Reno, offers a fascinating and thorough insight into the nature experience during this era. This hike occurred during the summer at Carson Pass. (Courtesy of Special Collections, University of Nevada, Reno.)

The Sierra Club, formed in 1892, was created in part to help people explore and enjoy the wilderness of the Sierra Nevada. Under the direction of Joel Hildebrand, the Sierra Club emphasized winter sports, developing wilderness skills, and teaching techniques for ski mountaineering. This is a portrait of an unidentified man, posing in his bathing suit, on skis. He doesn't even appear cold! (Henry Collection, courtesy of the North Lake Tahoe Historical Society.)

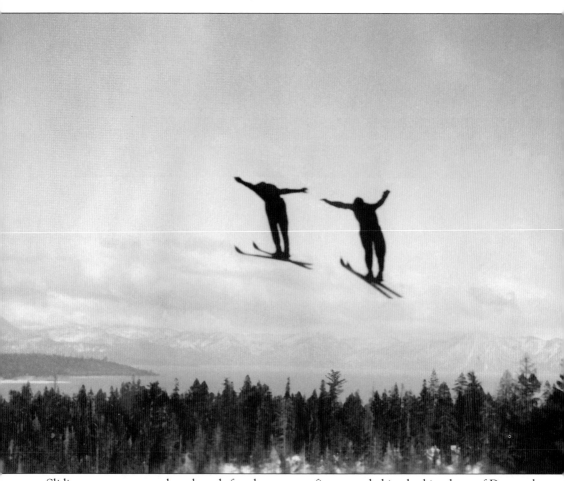

Sliding across snow on long boards for pleasure was first recorded in the kingdoms of Denmark and Norway in the late 18th or early 19th centuries. From these modest beginnings emerged a major industry. John A. Thompson, an immigrant, lived on a ranch near Sacramento and developed into perhaps the most famous early skier. He fashioned long boards, roughly nine feet long, four inches wide, with leather straps affixed to the center of the board to hold the toe of his boot. Cutting a long rounded pole, Thompson was soon carrying up to 100 pounds of mail across terrain nearly impassable by any other means, especially in heavy snowfall years. By 1859, skies were becoming an accepted if minor mode of winter transportation in the Sierras. Skiing remained localized, however, and a very informal activity during the later part of the 19th century. This is a photograph of two men frozen in mid-flight. A ski club was set up in Tahoe City by Bill Bechdolt and others in 1936, whereupon they built a single 1,300-foot-long rope-tow that took skiers up the mountain at the southern edge of Tahoe city. Therefore this is reputed to be the first ski hill in the basin. They conducted ski races, added a toboggan slide, and sponsored sleigh rides. But it was the 1960 winter Olympics at Squaw Valley that attracted international attention to the world class skiing at Lake Tahoe. (Henry Collection, courtesy of the North Lake Tahoe Historical Society.)

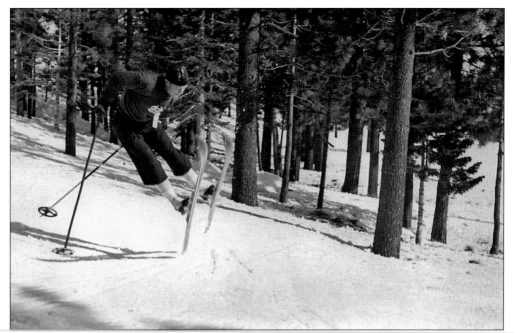

Playfulness is part of the sport of skiing. One only need notice how modern ski resorts cater to the acrobatic specialist in either skiing or snowboarding to gauge how attractive and dynamic this sport has become. This is a photograph of Al Henry made in 1947, and he is obviously "stuck." (Henry Collection, courtesy of the North Lake Tahoe Historical Society.)

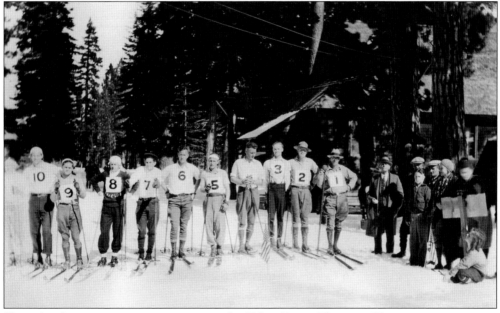

Skiing has become a major winter sport in the Tahoe Basin. There are 15 major resorts catering to those wishing to ski, snowboard, or simply sit by the roaring fires in the splendid lodges. This photograph shows an early, predominantly male ski team, and it is apparent that the gear has evolved along with the sport. Note the fedoras and leather, laced boots on many of the team members. (Henry Collection, courtesy of the North Lake Tahoe Historical Society.)

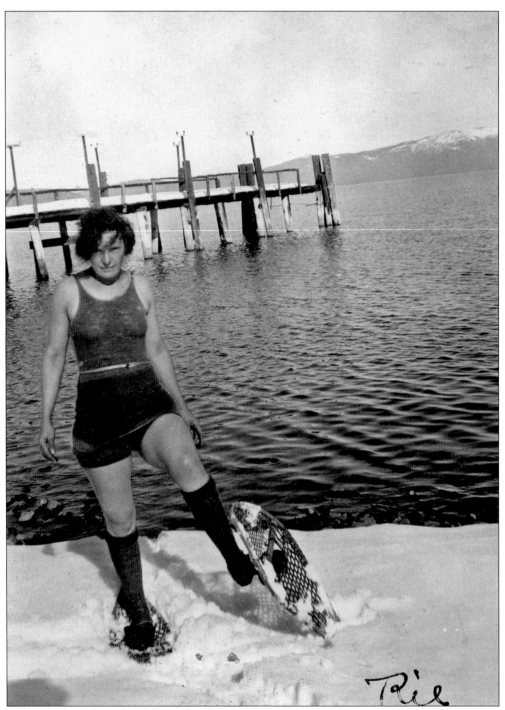

This is presumably a portrait of "Rie" posing in a swimsuit while snowshoeing along the lakeshore on January 8, 1928. (Henry Collection, courtesy of the North Lake Tahoe Historical Society.)

Seven

POSING

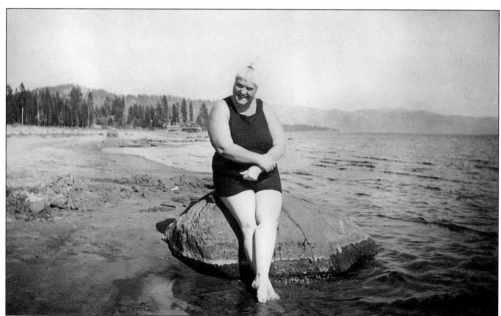

Of the many pictorial histories of Lake Tahoe, few dedicated much space to the vernacular, amateur photograph. Many images were inevitably lost over time, while others are removed from public view in private collections, stored in attics or basements, or in albums lined in rows on library bookshelves. In a few cases, however, individuals realize the importance of their photographs and donate entire collections to local historical societies. These private images can then become public history, such as this charming portrait of a woman in a swimsuit resting on a rock. (Henry Collection, courtesy of the North Lake Tahoe Historical Society.)

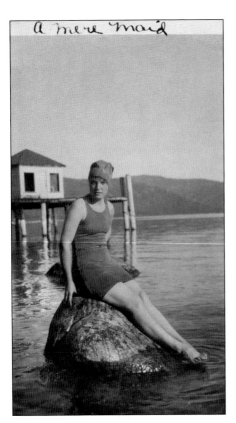

a mere maid

Another in a fascinating vernacular series, this photograph portrays the textual and visual pun, "A mere maid." Note that this unidentified woman wearing a fashionable bathing suit, including the accessorized hat, is sitting on a rock—making sure to keep her toes out of the cold Tahoe waters. (Henry Collection, courtesy of the North Lake Tahoe Historical Society.)

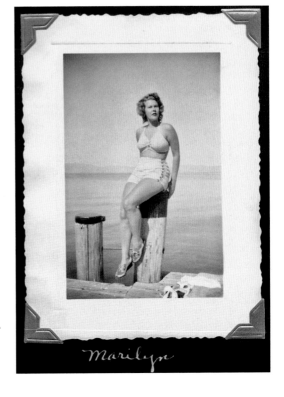

Marilyn

Vernacular portraiture often mimics professional photography of the era. This attractive view of "Marilyn" posing on one of the pylons at the Homewood pier in an early two-piece bathing suit resembles images in contemporary fashion magazines. (Photograph by Arlean Alvarez Arnaudo; Billie Crouch Cotton Album, courtesy of the North Lake Tahoe Historical Society.)

"Bob," balancing on two pylons at the Homewood pier, strikes a Grecian pose, pointing off to the right. Perhaps the style of the swimsuit reflects just such a classic reference. (Photograph by Arlean Alvarez Arnaudo; Billie Crouch Cotton Album, courtesy of the North Lake Tahoe Historical Society.)

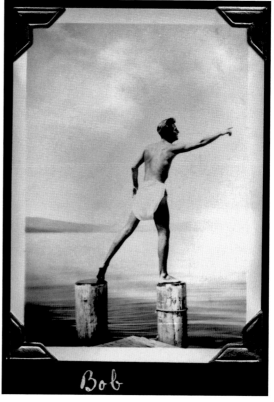

Bob

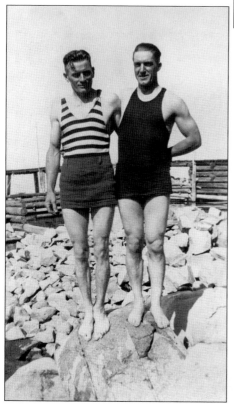

The waters at Lake Tahoe are usually cold, more so for those unaccustomed to swimming in alpine lakes. It takes a bit of mental preparation to jump into the water. Perhaps these two dapper unidentified gentlemen were posing just before making such a leap. This photograph offers a revealing look at swimsuit fashion during the early part of the 20th century. (Henry Collection, courtesy of the North Lake Tahoe Historical Society.)

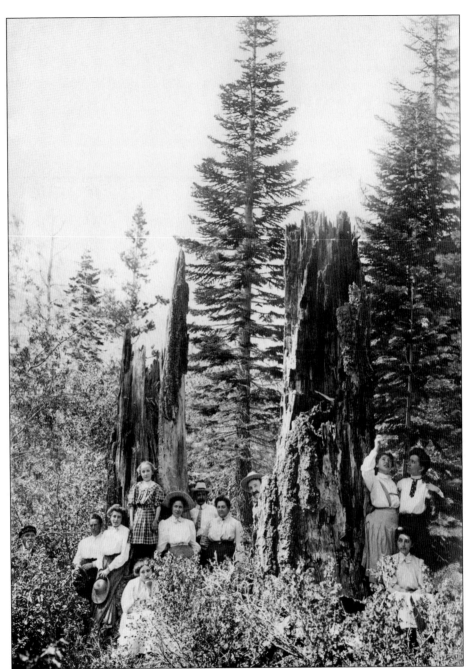

The opportunity to experience nature and still have all the comforts of a luxury resort nearby has made Lake Tahoe a desirable vacation destination. This photograph, a group portrait of the Cavell and Platt families on a Tahoe outing, is not an ordinary portrait. They arrange themselves around a visual history of the forest. The fire-damaged remnants of the old forest provide a backdrop of a grand natural history. Note that each individual is dressed in their Sunday best, yet a few are hidden within the brush, or peeking out from behind the stately remains. All this posing didn't appear to engage everyone, however, as seated in the front foreground (left) is a young lady who looks quite bored with the entire experience. (Courtesy of the Nevada Historical Society.)

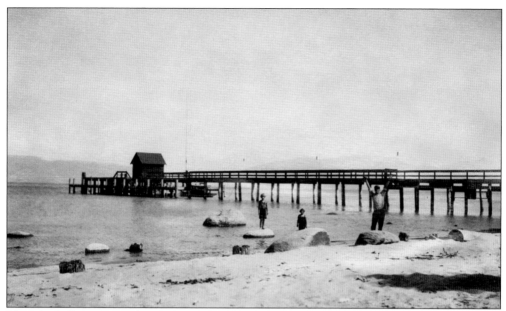

The Newhall estate was founded by the George Newhall family of San Francisco, and consisted of 273 acres along Rubicon Bay. On a knoll above the lake, the family built a three-and-a-half-story mansion, including this large boathouse and pier along the lake frontage. This photograph, made in 1926, includes Rad, Joy, and Mary Kiefer. Note that Mary, at left, appears to be floating in space. (Courtesy of Special Collections, University of Nevada, Reno.)

Hans Hansen, pictured here with two dogs and an automobile dubbed the "Spirit of Lake Tahoe," was the caretaker of the Newhall estate. This photograph was made by the shadowy figure seen at lower right, in 1927. (Courtesy of Special Collections, University of Nevada, Reno.)

Female photographers are underrepresented in the history of the art. This is only the second photograph in this volume of a woman photographer (see page 64). Unfortunately both photographers remain unidentified. In this 1940s image, our photographer is standing next to the remains of a very early day V-flume in the lower Tahoe Meadows to the west of Washoe Valley. This flume was part of the timbering operations of Orson, Hyde, and Price and was used, along with other branches, to deliver firewood to Ophir City and later to the Virginia and Truckee Rail Road. In its time, the V-flume was an important engineering development. While the V-flume used greased walls and a constant flow of water to shoot logs and cordwood down to the mill, it was also occasionally used as a thrill-ride, resulting in either injury or severe admonishment by flume men working nearby. Today hikers can still find pieces of old planks, square nails, or a shallow trench marking the route of this V-flume, as shown above. (Photograph by Walt Mulcahy; courtesy of the Nevada Historical Society.)

Eight

WILDLIFE HARVESTING

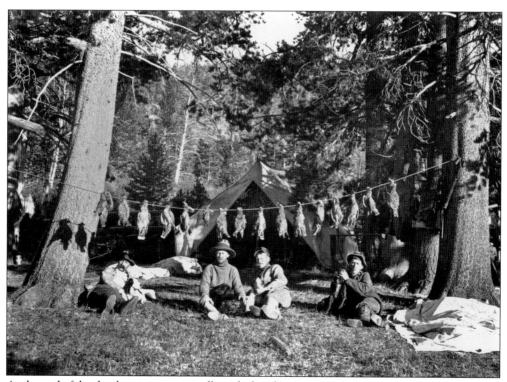

At the end of the day, hunters pose proudly with their bounty, a row of game birds. Early perceptions of Lake Tahoe were that the lake, and the surrounding landscape, offered unlimited supplies of wildlife for harvest. During Tahoe's early settlement days, camping was an inexpensive method of visiting the lake, and hunting permits were not required. (Courtesy of the South Lake Tahoe Historical Society.)

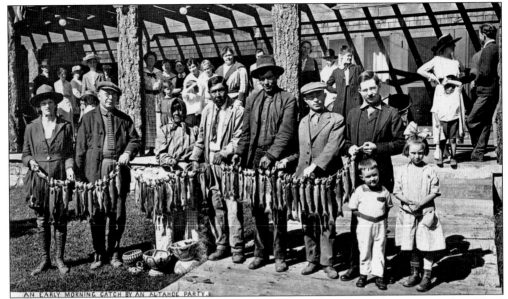

The hotel identified here as Al Tahoe was first completed in 1859. Al Tahoe became the official name in 1907, when Al Sprague merged his first name with Tahoe to identify the resort. Its beginning as an angler's paradise is reflected in this portrait of "an early morning catch by an Al Tahoe party." Note how they are dressed. With the exception of the Washoe woman, they appear in recreational costumes of the era. (Courtesy of the South Lake Tahoe Historical Society.)

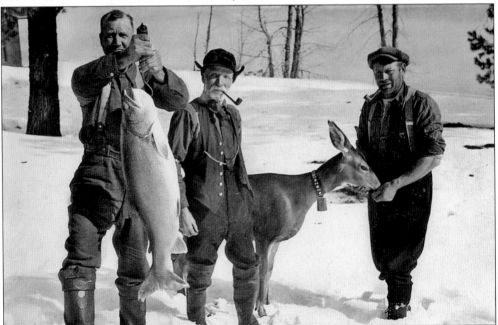

The earliest recording of Euro-American fishing in Lake Tahoe was in 1859, when a fishery was established on the southeast shore of the lake. This photograph documents the catch by Ernest Pomin, a 24-pound mackinaw trout caught off Sugar Pine Point, *Happy Day* captain Joe Pomin, Mary, a black-tailed deer, and the self-proclaimed, "King of the Woods," in the spring of 1920. (Henry Collection, courtesy of the North Lake Tahoe Historical Society.)

Emma Lawrence is posing with a large catch and oar, leading viewers to imagine that she clubbed the fish into submission. Female anglers made headlines in the early days of Tahoe's history. In May 1895, the Fish Commission, antecedent to the California Fish and Game Commission, introduced 65,000 exotic mackinaw fingerlings, voracious feeders that can reach upwards of 30 pounds each. (Courtesy of the South Lake Tahoe Historical Society.)

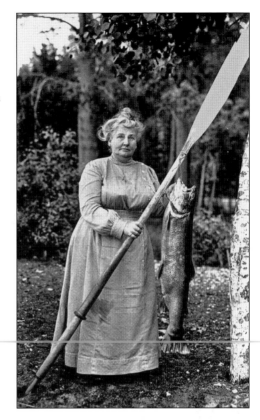

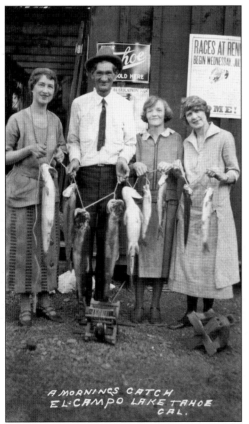

This 1925 postcard shows "A Mornings Catch El Campo Lake Tahoe Cal." El Campo was a campground run by "Old Bill" Johnson, hunter, commercial fisherman, and opponent of Prohibition. According to Edward B. Scott, "Old Bill" used to hide bottles of "Sierra chain lightning" under logs, littering the Tahoe landscape. El Campo is near Homewood. Note that these anglers do not wear the clothing of serious fishermen. (Courtesy of the North Lake Tahoe Historical Society.)

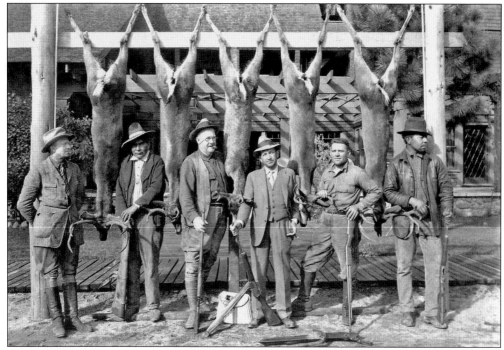

In 1924, Frank Globin from Marysville, California, purchased Al Tahoe, thereafter operating the resort for more than three decades. Hunting is another recreational sport offered through Globin's Al Tahoe Resort. The person on the far left is probably the guide. A community unto itself, Globin's Al Tahoe boasted a hotel, post office, store, and dance hall until 1956, when a fire nearly destroyed the entire facility. (Courtesy of the South Lake Tahoe Historical Society.)

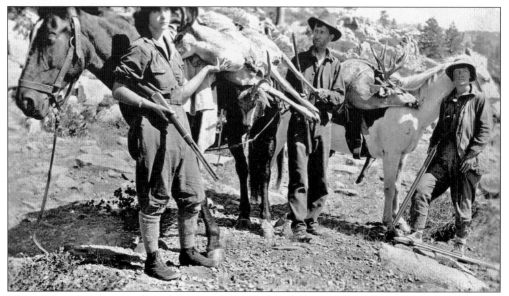

This photograph has no identification, although female hunters—and serious looking ones at that—are highly unusual. The hunt appears successful. (Courtesy of the South Lake Tahoe Historical Society.)

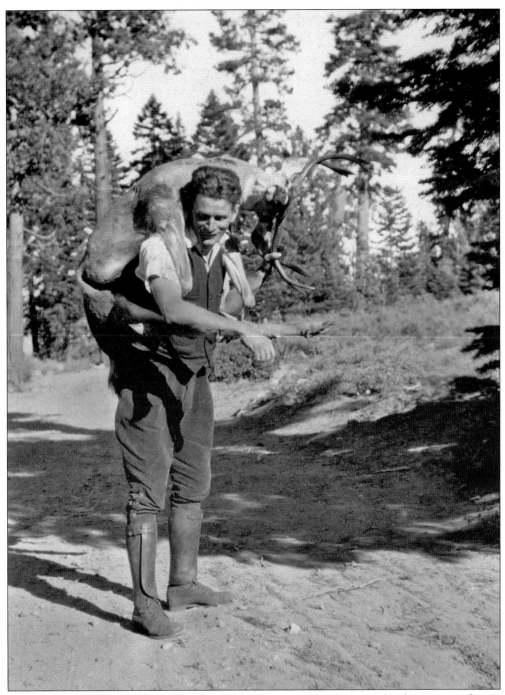

After pervasive logging subsided in the Tahoe Basin, tourism became the dominant industry. Nearly every resort catered to the traveler, health seeker, vacationer, excursionist, angler, skier, boating enthusiast, and of course, the recreational hunter. This photograph is composed in such a manner that it appears as if the deer are ripe for harvest. All that is necessary is to walk into the landscape and grab one. (Henry Collection, courtesy of the North Lake Tahoe Historical Society.)

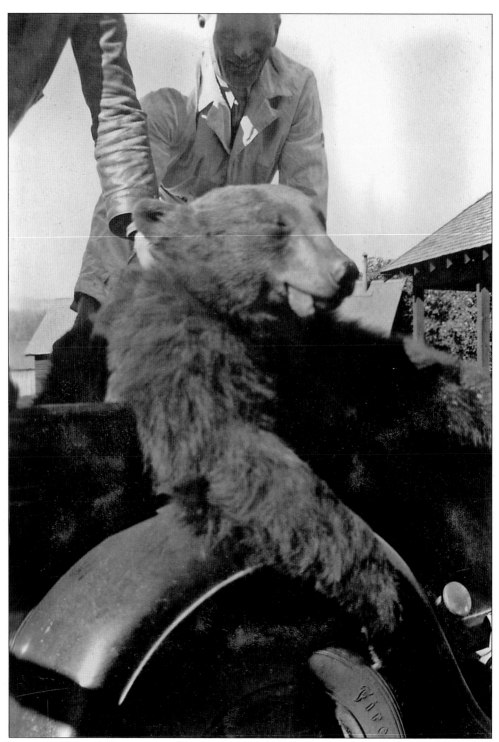

The automobile, the unconscious bear, and the smiling man wearing a white coat—This image tempts viewers to imagine a story about the inevitable collision of technology and wildlife. (Henry Collection, courtesy of the North Lake Tahoe Historical Society.)

Nine

EPILOGUE AND CINEMATICS

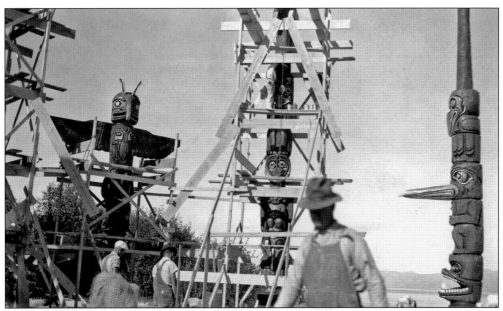

This photograph documents the construction of a totem pole for the movie *Rose Marie, An American Tragedy* (1936), which was filmed, in part, at Cascade Lake. The setting of the movie, however, was intended to appear as if the action took place in northwest Canada. The movie is a love story between a Canadian opera singer, played by Jeanette MacDonald, and a Canadian mounted officer, played by Nelson Eddy. They fall in love, and, usually accompanied by a full orchestra in the background, communicate through song. The film's most memorable signature number is their glorious duet, "Indian Love Call." (Courtesy of the Nevada Historical Society.)

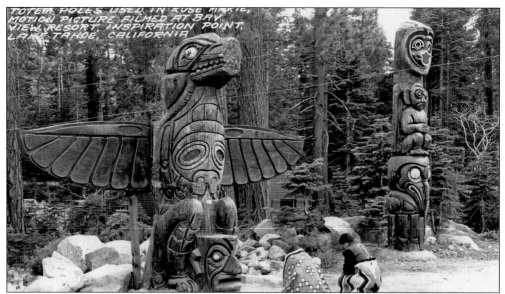

Rose Marie was also filmed at the Bay View Resort (Lakeview Lodge) south of Inspiration Point, the panoramic promontory at the southwestern edge of Emerald Bay. The totem poles and winged birds became tourist attractions, as this postcard attests. (Courtesy of the North Lake Tahoe Historical Society.)

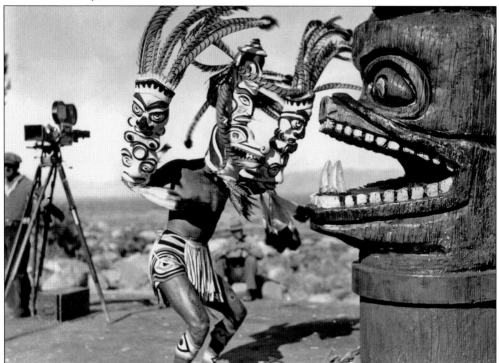

The movie camera, left, and the costuming identify this as another setup for the movie *Rose Marie*. During the 1930s, it was much easier for Hollywood producers to simulate a Canadian landscape using Lake Tahoe's alpine landscape. (Henry Collection, courtesy of the North Lake Tahoe Historical Society.)

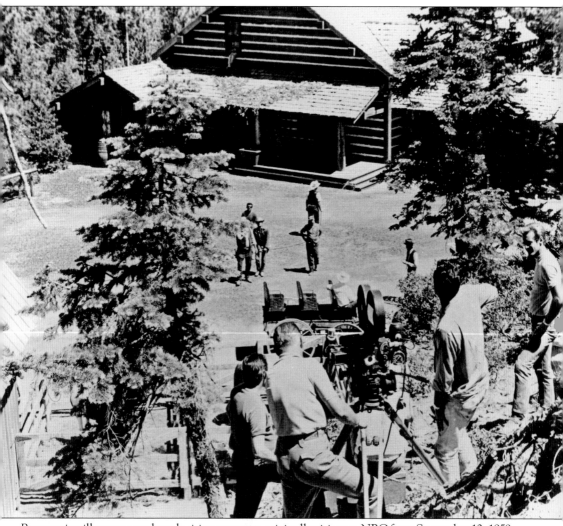

Bonanza is still a very popular television program, originally airing on NBC from September 12, 1959, to January 16, 1973, and surviving in syndication ever since. This hour-long western drama, filmed on location near Incline Village in Lake Tahoe, chronicled the adventures of Ben Cartwright, the patriarch and wealthy owner of a large ranch called the Ponderosa. Ben Cartwright was widowed three times, and had a son by each of his wives. The eldest son was Adam, the middle son Hoss and youngest son, Little Joe. Unlike other programs of its era, *Bonanza* was filmed in color from the outset, a decision meant to help *Bonanza*'s sponsor, RCA, sell more color television sets. The theme park named the Ponderosa Ranch, Incline Village, was based on the *Bonanza* television location set. The Ponderosa Ranch opened in 1967 and every year approximately 300,000 visitors from around the world have kept alive the memory of one of television's most famous families, the Cartwrights (the most famous according to the historical marker near the ranch house). Since it first aired in 1959, followed by more than 831 original episodes broadcast into 86 countries and 12 different languages, "the Cartwright Ranch House has been the ever-present star in a television legacy that will live on forever." This photograph documents one of the segments being filmed for broadcast. (Courtesy of the Nevada Historical Society.)

Nearly every winter destination resort has some sort of winter carnival. Pictured here is the crowning of the Snow Princess, included in the Marie Henry Album at the North Lake Tahoe Historical Society. While there are many unusual and beautiful lakes throughout the Sierra Nevada, Lake Tahoe is its crown jewel. Photography is more than a simple recording of history; it is created. Whether it is through documented ritual, directorially created views, posed portraits, or just the inevitable selective process by which certain images survive and proliferate, our knowledge of our past must involve an understanding of the interpretive quality of the photographic image. It is true that "the illiterate of the future will be ignorant of the use of the camera and pen alike." (Courtesy of the North Lake Tahoe Historical Society.)